cool nail art

hannah lee

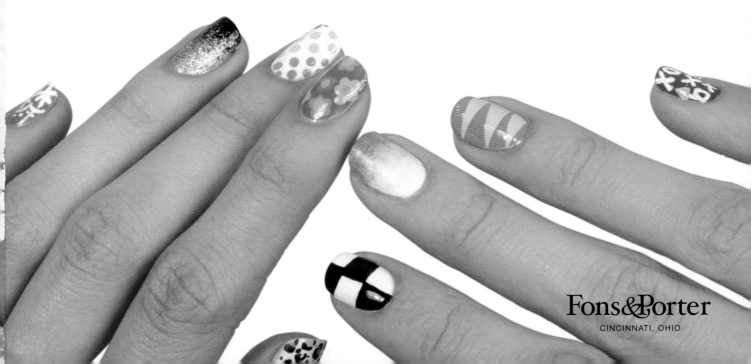

Fons&Porter
CINCINNATI, OHIO

contents

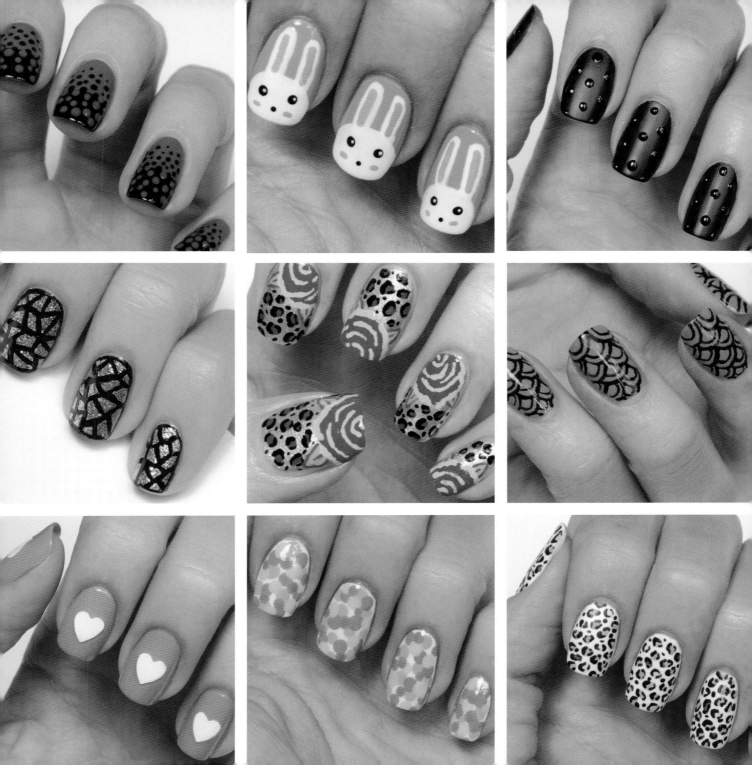

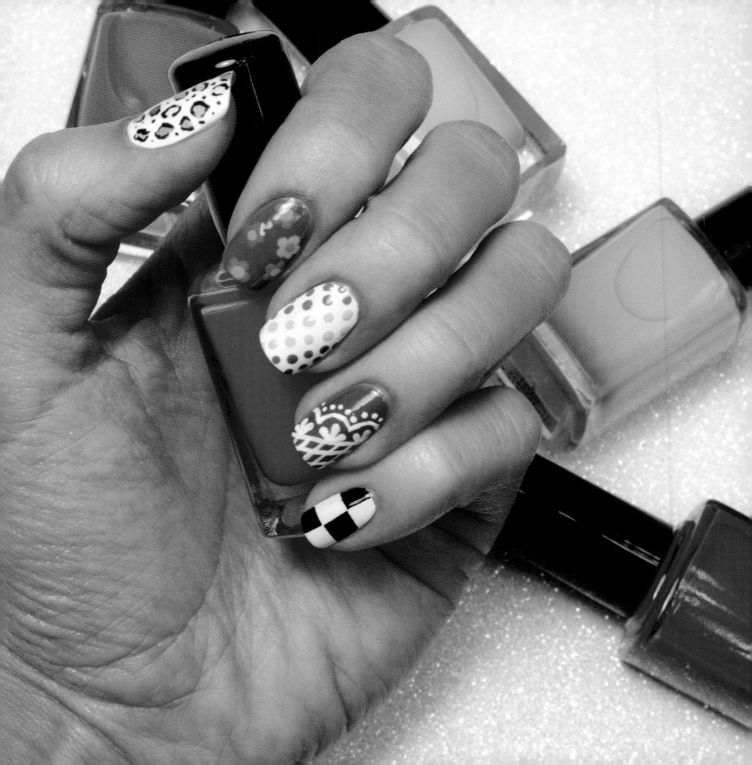

introduction

Nail art has become one of the best accessories you can add to your look. Whether you want to dress it up, draw attention or keep it casual, you have so many options to choose from. You don't need to be a professional manicurist to create awesome nail designs. With a little practice, the right tools and the step-by-step tutorials found in this book, you'll be creating your very own nail art in no time.

As cliché as it may sound, practice does make perfect. Don't get discouraged if you don't get it right on the very first try. Certain techniques may take some getting used to, and it's okay to make mistakes. Just be patient, keep trying and, before you know it, it will become easier and feel more natural.

Nail art is a great way to express yourself and your style. It's like having small canvases on your fingers, and everywhere you go, you can share your art. The best part is you can design your nails however you like! Change up the colors you find here, mix and match with just an accent nail or stick with the original look. It's all up to you!

There are some important things you should know before you start your nail art project. Great-looking nail art is not only about the design but also about preparation. You may be tempted to skip the prep work, but these tips and techniques will give you clean, healthy nails and help your manicure last longer.

Prepping Your Nails

The best way to prep your nails is to establish a simple nail care routine. Start by shaping your nails with a nail file. The five most popular nail shapes are square, oval, squoval (square oval), round and almond (pointed). Review the shapes at right to determine which one fits you best. The designs in this book don't require any specific shapes.

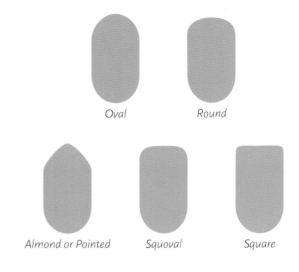

Oval *Round*

Almond or Pointed *Squoval* *Square*

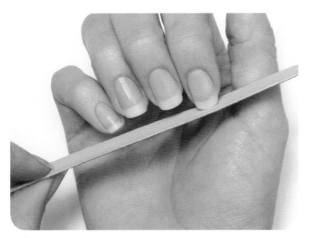

1 File each nail in a single direction. Filing back and forth can be too harsh for the nail and could possibly cause damage.

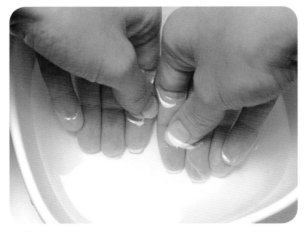

2 If you have any dead skin around your cuticles, soak your nails in a bowl of warm water for five minutes. This will soften the skin.

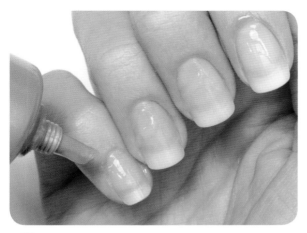

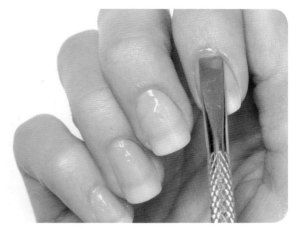

3 Apply a cuticle remover around each cuticle, following the manufacturer's instructions for how long to let it set.

4 With a pusher, gently push the cuticles back slightly. This will remove any dead skin and create a better area for designing.

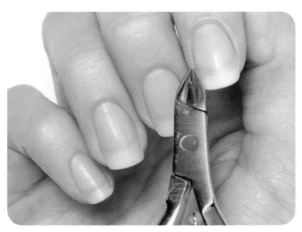

5 If you have any hangnails, carefully clip them with a pair of nail clippers.

Hydrating Your Nails

It's important to keep your hands and nails moisturized.
Cuticle oil and hand cream are a great way to get this
job done.

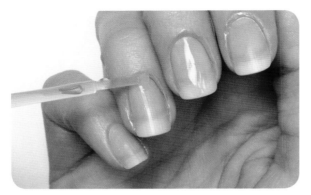

1 Apply a drop of cuticle oil to each nail.

2 Massage the oil into each nail.

3 Apply your favorite lotion to your hands to moisturize them as well.

4 Allow the cuticle oil to soak in for at least five minutes. To create a good sticking base for your nail art, remove the cuticle oil by applying rubbing alcohol to a cotton swab and wiping the nail bed.

Tools and Techniques

Some essential tools and techniques will help you achieve the best results for your designs. These tools are not hard to find or expensive, and some are household items you might already have. If you cannot find these items in your local store or beauty supply, you can easily find them online.

Once you are prepped and ready for nail art, always apply a **base coat** to your nails first. A base coat is a product made specifically to prolong the life of your manicure. A base coat protects your natural nail from staining, fills in lines to create a smooth surface and helps polish adhere to the nail.

When you are finished with your design, it is crucial to end with a **top coat** that will protect your manicure. A top coat is a product that smooths out any imperfections, seals in your manicure for the best protection against chipping and gives a shiny finish. Some top coats used in this book are matte, which means they are flat and without shine. Make sure you also apply top coat to the free edge (front tip) of your nail for maximum protection.

A **dotting tool** is one of the most popular nail art tools. This tool usually has two rounded ends of different sizes, one on each end of the handle. It's used to create patterns and shapes for your designs. Smaller dotting tools can also be used for applying tiny details in a design. To use this tool, apply a small drop of polish or acrylic paint to a plastic sandwich bag, then dip just the tip of the tool into the polish and gently apply dots onto the nail. The more polish you get on the tip, the larger your dot will be. If you are creating a different shape with the tool, such

Dotting tools

as outlines for a cheetah print, it's best to glide the tool along without pressing too hard. Gentle pressure ensures you don't drag the tool into your base polish and ruin the design.

A **small nail art brush** is great for applying colors and details. You can find packs of these in all different shapes and sizes online or in beauty supply stores. You can use standard small paintbrushes as an alternative. To use this brush, apply a small drop of polish or acrylic paint to a sandwich bag and dip the tip of the brush into the polish. Carefully paint the nail as you would with a regular

Small nail art brush

paintbrush. Remember to clean your brushes after each step to lengthen the life of your tools. Acrylic paint is easy to remove: just rinse the brush with water. If you are using polish, dip the tip of the brush into acetone polish remover and wipe it with a paper towel.

Acrylic paint is an excellent tool for doing nail art. Many manicurists and nail artists use it to create amazing designs. It is easier to apply than polish because of its consistency. It's perfect for applying details (not the base coats) and comes in a wide variety of colors. Acrylic paint is the same type of nontoxic paint you find in craft stores. The great thing about this paint is, when it's still damp, you can wash it away with water, so if you make a mistake, you can wipe it away. As mentioned before, acrylic paint is best for details and is less effective when used directly on the nail. Nail polish adheres to the nail best, so always use a clear base coat, then use polish for your base color. It's always important to finish any manicure with a top coat, but this is especially true if you use acrylic paint in your design since it's water soluble.

Stripers or striping brushes are required for applying long lines or stripes. Striping brushes are usually found in packs of nail art brushes, or you can purchase them separately. You can also use colored stripers that come in the caps of bottles conveniently filled with one color; these bottles will be labeled as stripers.

Some designs require the use of tape to complete a shape or pattern. **Painter's tape** is a great option because it's not as tacky as other tapes. You can cut the tape to any size you might need, and it's strong enough that it won't break when you remove it from the nail. **Striping tape** is

Striper

Painter's tape

Striping tape

Makeup sponge

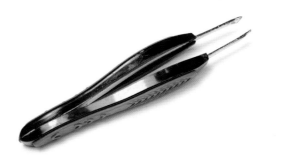

Tweezers

another essential tool because it's very narrow and allows you to create thin, consistent lines, which would be difficult to make if you were to try cutting the tape yourself. Whichever tape you use, it's important to let your polish dry completely before you apply tape. If you feel the tape is too tacky, place it on the back of your hand and remove it once to lessen the stickiness. It is important that you remove the tape while the polish is still wet in order to achieve the cleanest lines.

A **makeup sponge** is the best tool for creating textures and gradients because it's a small, porous surface. To apply polish or acrylic paint using the sponge, cut off a small piece and grab it with a pair of tweezers. Have a drop of polish or acrylic paint ready on a plastic sandwich bag. Dip the sponge into the color, then carefully sponge it onto the nail. Using **tweezers** makes this process much easier and less messy. Tweezers also come in handy when removing tape from a design.

A **toothpick** is another great tool for creating nail art. It can be used as an alternative to the dotting tool or to apply tiny details. Its small tip is perfect for picking up only a slight amount of polish or acrylic paint. For the best results, dip the tip into the product and carefully glide the color onto the nail. Do not press down too hard or you may scratch the layers of your manicure.

Nail Tips

You may wonder how others get their manicure looking so good. Maybe there are some nail painting secrets you don't know? Yes, there are! In this section, you'll find troubleshooting tips for how to perfect your manicure.

KEEPING STEADY

Applying polish is one of the most basic steps in nail art, yet it can be troublesome. If you have shaky hands, place your pinky finger on something solid when you're applying polish. This can take some getting used to and may feel awkward at first, but it will help steady your entire hand.

Practice makes perfect, and this definitely applies for polishing with your nondominant hand. Use the techniques below and take your time. Don't worry if you're not perfect. It'll become more natural the more often you practice.

Steady your hand by keeping your pinky on the table.

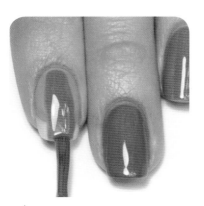

1 Make sure you have enough polish on the brush, then start near the cuticle in the center of the nail and sweep the polish down.

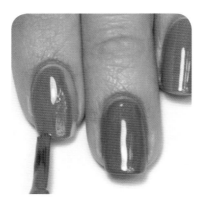

2 Do the same on the left side.

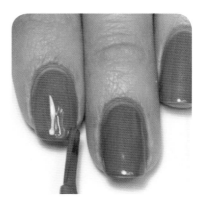

3 Paint the right side and blend it in.

AVOIDING BUBBLES

Another problem you may run into are bubbles appearing after you apply polish. This problem usually occurs when you vigorously shake the polish bottle before you apply. Instead, gently roll the bottle between your hands to prevent bubbles from forming. Also, make sure you're not applying your polish layers too thick. This may take some trial and error, but try to finish with layers that are not too thick and not too thin. The polish should be flat, and it should not be thick enough to bump up from the nail. Typically you need two coats of polish to make the coverage opaque.

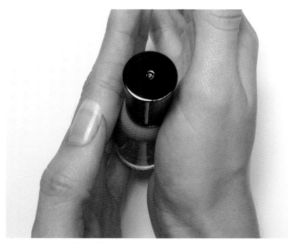

Roll polish to mix rather than shake it.

REMOVING POLISH FROM CUTICLE AND SKIN

If you accidentally get polish onto the cuticle area, it's easiest to remove it before it dries.

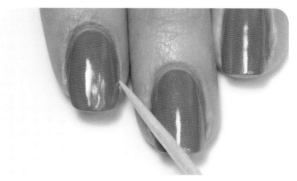

1 Take a toothpick or something else that is small and thin (like a business card), and gently remove the polish from the skin.

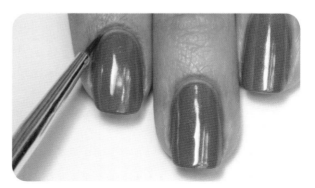

2 If the polish has already dried, dip a small brush into polish remover and carefully brush away the unwanted polish. Polish remover can dry out your skin, so be sure to restore moisture with cuticle oil after your manicure is completely dry.

GROWING STRONGER NAILS

If you're wondering how you can grow longer and stronger nails, a few key practices will help. Good nutrition plays a big part in nail growth and nail strength. First, be sure to eat healthy and to hydrate with water. Next, keep your hands and cuticles moisturized. This helps keep them healthy and looking good. Moisturize your hands with hand cream and apply a drop of cuticle oil to each nail. Gently massage the oil into your nails and cuticles. Doing so increases blood circulation, which can help your nails grow, too.

DRYING NAILS

Have you ever painted your nails and then realized they weren't going to dry in time? A few faster-drying methods can help. You can use a quick-drying top coat. This type of top coat penetrates each layer of polish to quicken the dry time. Another alternative is fast-drying drops. Just a couple drops on each nail set your manicure in about sixty seconds. Don't have drops? No problem! After you finish your manicure, submerge your nails in a bowl of ice-cold water for about two minutes. Nail polish dries when it encounters cool temperatures. You can also stick your hands in the freezer to quicken the curing time.

Blow-drying your nails can help, too. Make sure the blow dryer is about 10" (25.4cm) away from the nails, set on low and cool. Cooking spray also works well to cure your polish. Just mist the nails, let it set for about two minutes, then wash off the oil with water.

Lastly, let each layer of nail art dry before you start the next. Doing so prevents mishaps like smearing and smudging and helps you achieve the best outcome.

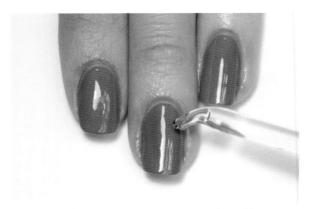

Use fast-drying drops to dry your nails quickly.

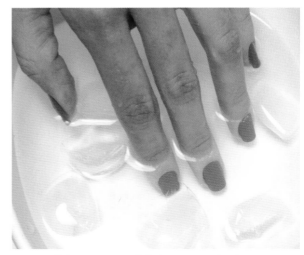

Submerge wet nails in ice water to dry them.

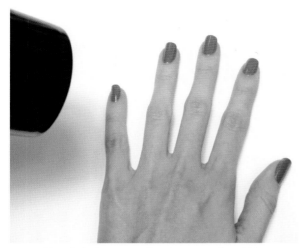

Set a hair dryer on cool to dry your nails quickly.

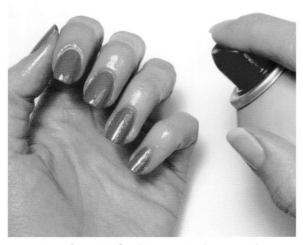

Use a fine mist of cooking spray to dry your nails.

Smearing and smudging can also occur as you're applying the top coat. Multiple strokes of top coat can loosen the layers underneath and cause problems. It's best to keep the strokes of top coat to three at most.

Toe Tips

When painting your toes, always separate the toes using cotton balls or toe separators to make the polishing easier.

Because you have to reach down to paint your toes, it may feel a little awkward. It's important to find a position that's comfortable and stable so you won't accidentally move or slip.

Also, if your smaller toenails are very short, you can use a dabbing motion to apply the polish since the area you have to cover is so small.

You can paint almost any design on your large toe because it's such a big canvas, then paint the other toes a matching color. Some of the most popular designs for toes are prints, such as floral or polka dot.

dotted and decaled nail art

The dotting tool makes simple yet fun nail designs that are perfect for the beginner. The projects in this chapter will teach you how to use the tool in different ways to fashion a variety of designs, from playful to elegant. Later in the chapter, you'll learn how to make your own nail polish decals.

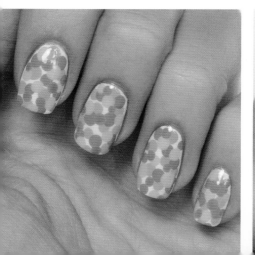
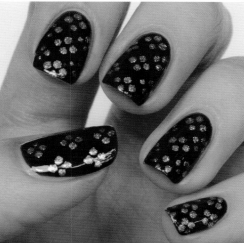
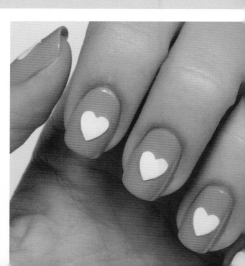

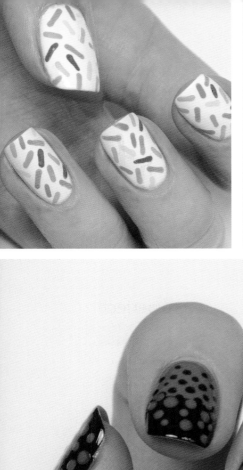
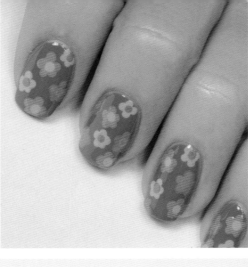
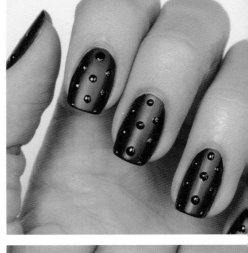
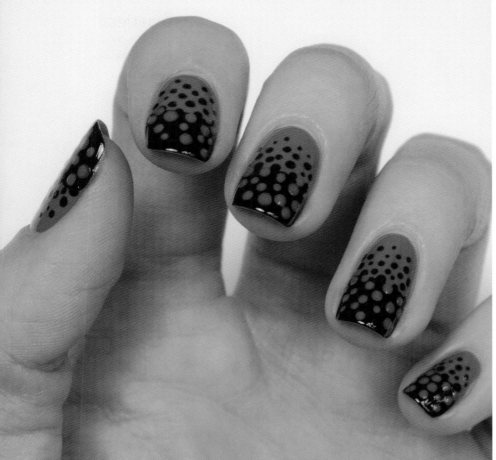
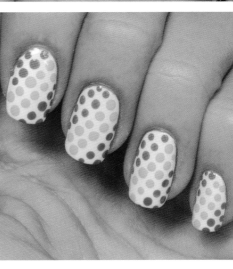
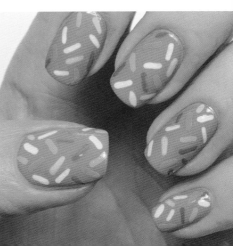

Neon Dots

This vibrant design is great for summertime.

1 After your base coat has dried, paint your nails using a white polish.

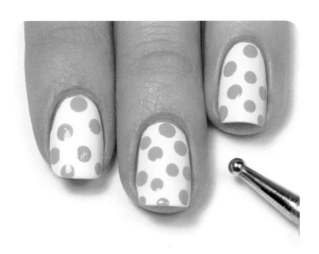

2 Dip a dotting tool into a lime green polish and apply random dots onto the nail.

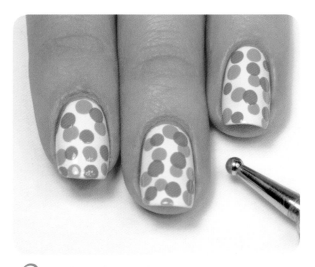

3 Wait for the first set of dots to dry, then continue to apply random dots using an orange polish. It's okay to overlap dots from the previous color.

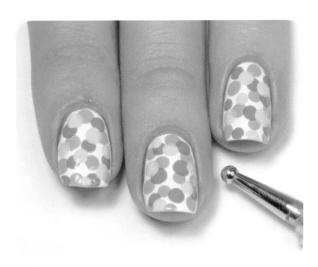

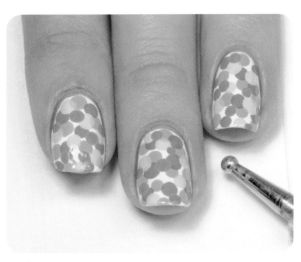

4 Apply another set of dots, this time with yellow polish.

5 Apply the last set of dots using a pink polish.

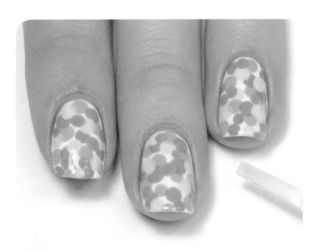

6 Finish with a top coat to seal in the design and protect your manicure.

toes, too!

This design looks great on both fingers and toes.

variation

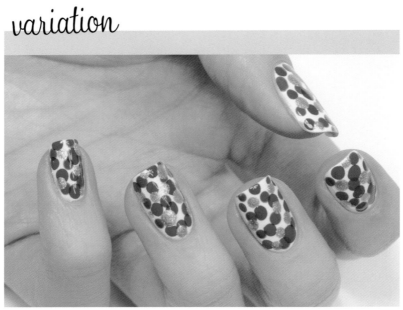

Turn this design into the perfect holiday manicure by choosing festive colors!

Candy Dots

These candy dot nails are fun and colorful
for any time you want a sweet manicure.

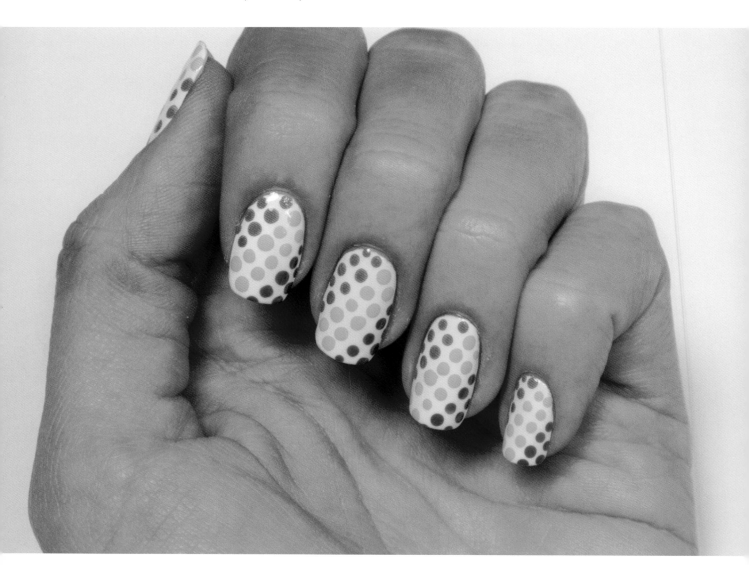

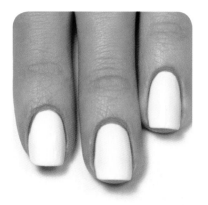

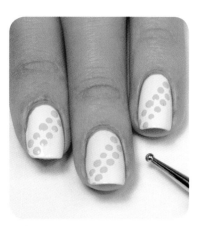

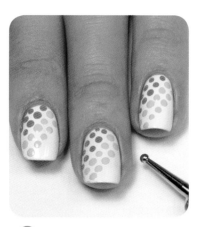

1 After your base coat has dried, paint your nails using a white polish.

2 Use a medium dotting tool to apply two rows of dots with yellow polish diagonally across the middle of the nail.

3 With the same dotting tool, apply two rows of dots with hot pink polish diagonally to the upper corner of the nail.

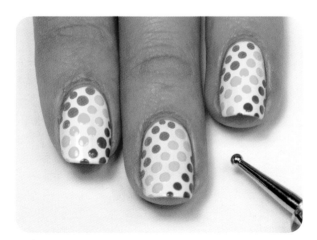

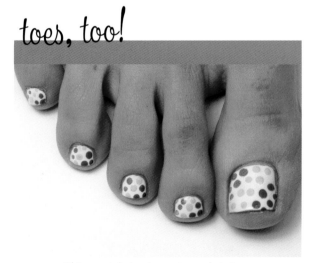

toes, too!

4 With the same dotting tool, apply two rows of dots with blue polish diagonally to the lower corner of the nail. Finish with a top coat to seal in the design and protect your manicure.

This sweet design is easy to apply to toes. Just use fewer dots on smaller nails.

Matte Studs

This studded matte design is a lot simpler than you'd think and a great way to try something new.

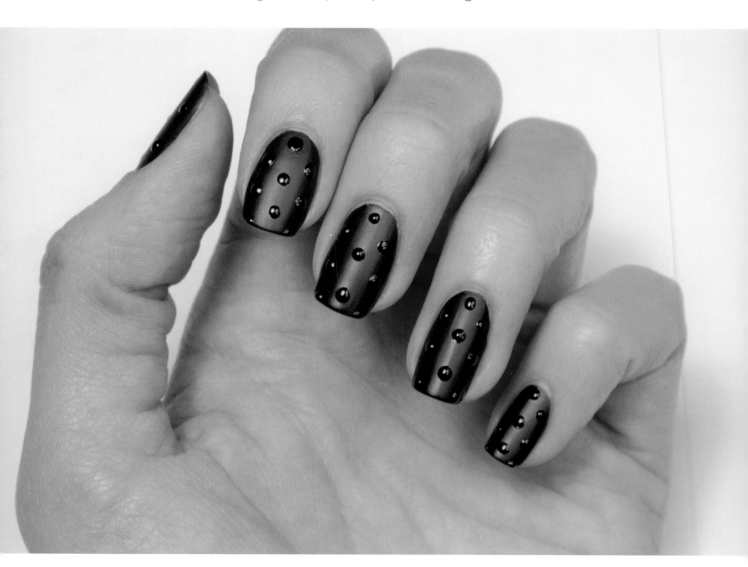

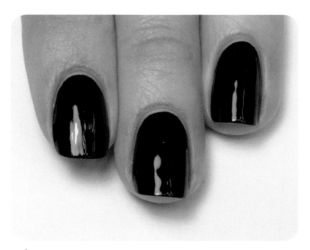

1 After your base coat has dried, paint your nails using a black polish.

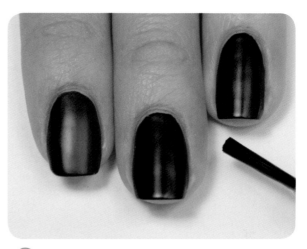

2 Apply one layer of a matte top coat to remove the shine from your polish.

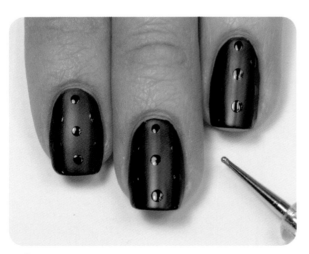

3 Use a small dotting tool and a clear top coat to apply uniform dots.

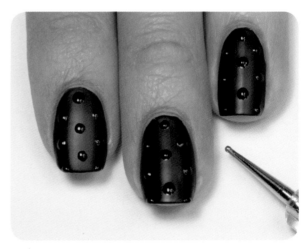

4 Finish by repeating the previous step over the same dots to create the textured effect.

Glitter Dots

This classy design is great for every occasion from prom to holiday parties.

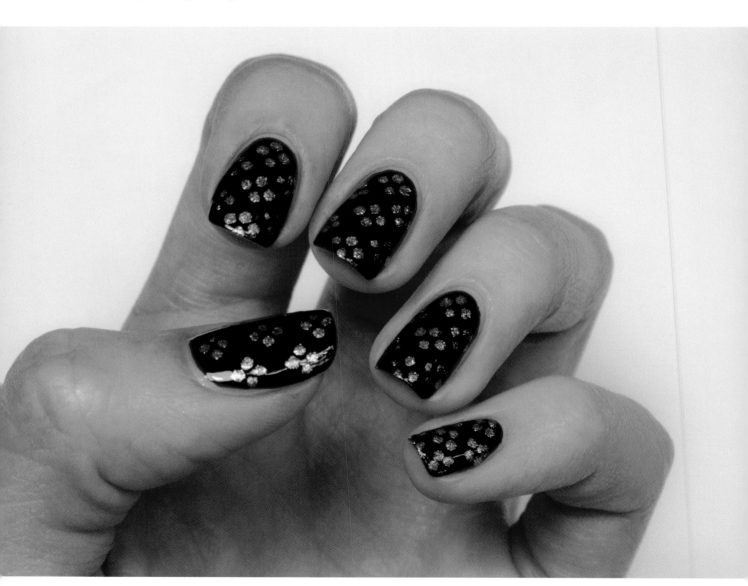

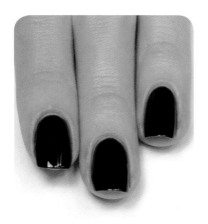

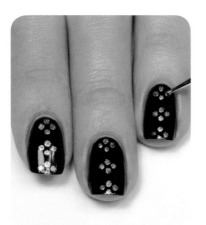

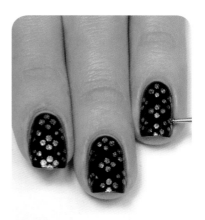

1 After your base coat has dried, paint your nails using a deep burgundy polish.

2 Use a small dotting tool to apply three clusters of four dots each down the center of the nail with glitter polish. Cluster the four dots into a diamond shape.

3 With the same tool and polish, apply clusters of dots to each side of the nail. Space these clusters between the clusters in the center to complete the pattern.

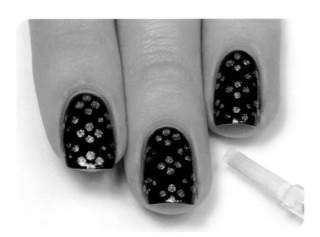

4 Finish with a top coat to seal in the design and protect your manicure.

toes, too!

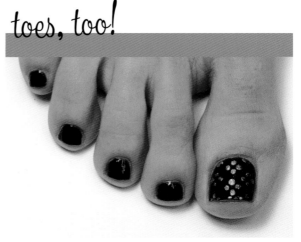

Apply this design to your big toe for an elegant accent.

Abstract Bubbles

If different is your thing, try this abstract bubble design.

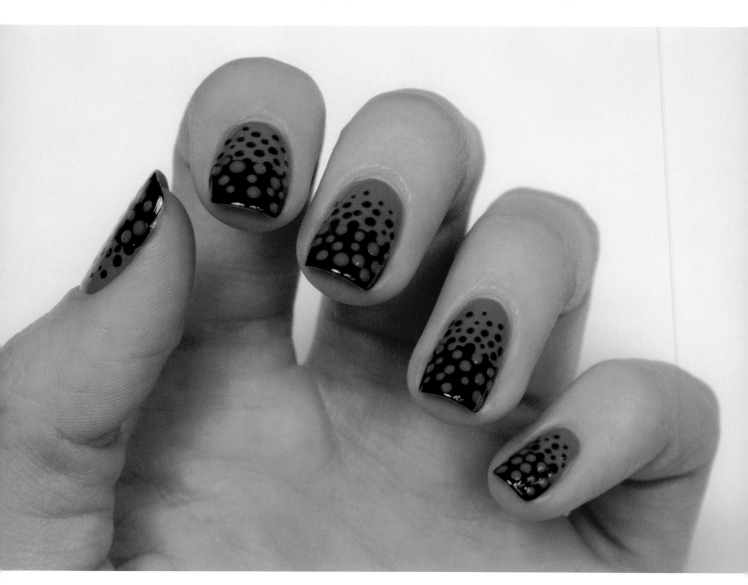

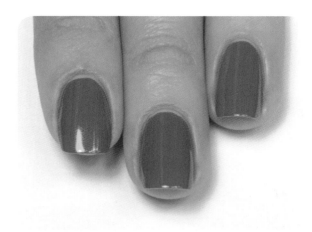

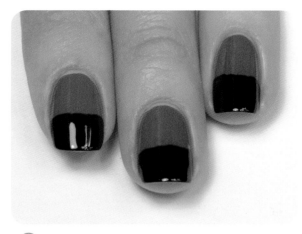

1 After your base coat has dried, paint your nails using a pink polish.

2 Apply black polish to half of your nail.

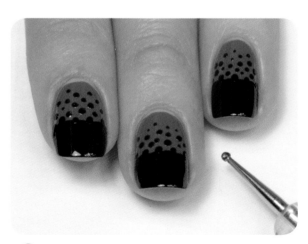

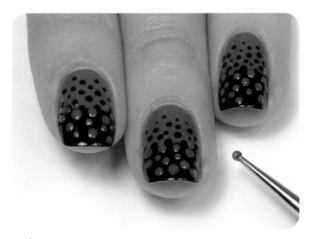

3 Use a small dotting tool and black polish to apply dots as if they were coming from the black polish and going into the pink.

4 Use the same dotting tool and the base coat's same pink polish to apply dots from the pink polish down into the black. Finish with a top coat to seal the design and protect your manicure.

Mod Flowers

This is the perfect design to go with your favorite spring and summer wardrobe.

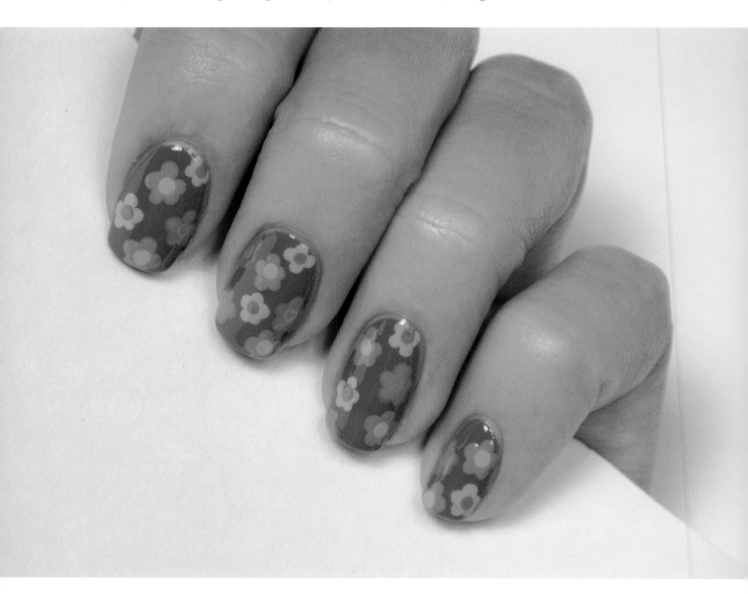

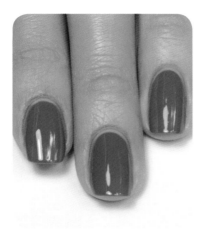 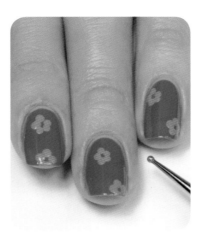 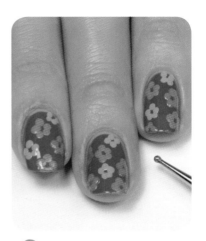

1 After your base coat has dried, paint your nails using teal blue polish.

2 Using a small dotting tool and hot pink polish, apply five dots in a circle to create a flower. Do this in random areas on the nail.

3 Repeat the previous step using lime green and orange polish for the petals.

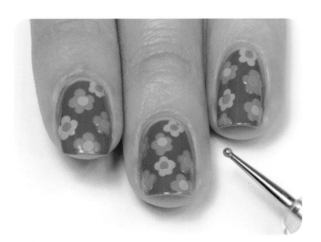

4 Use the dotting tool to apply a single dot in the middle of the flowers. Make sure the dot is a different color than the petals. Finish with a top coat to seal in the design and protect your manicure.

toes, too!

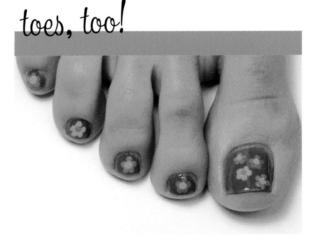

To adapt this design for your toenails, paint one flower on each of the smaller nails and create a cute flower arrangement on the big toe.

Rainbow Sprinkles

This sprinkle design is a cute way to express your sweet tooth!

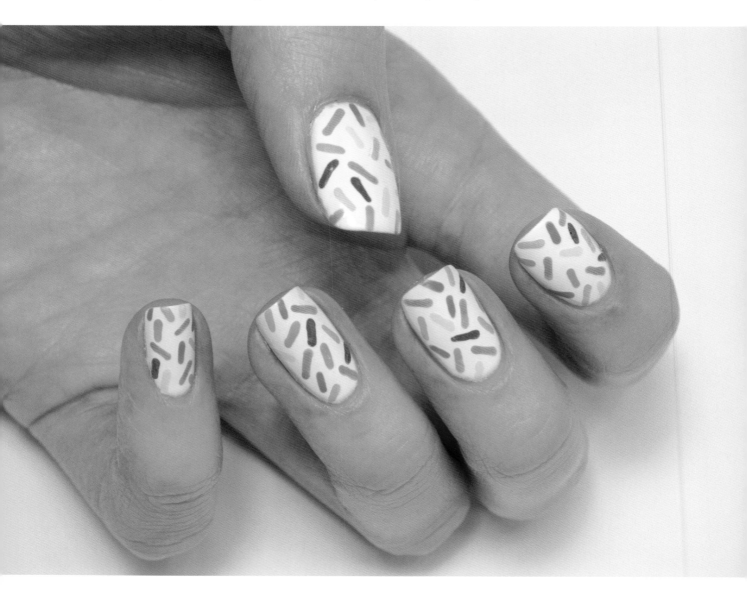

1 After your base coat has dried, paint your nails using a white polish.

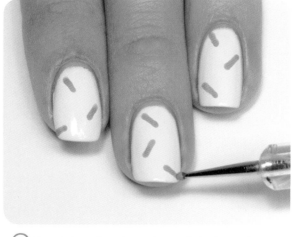

2 Use pink acrylic paint and a small dotting tool to apply thin lines randomly to the nail.

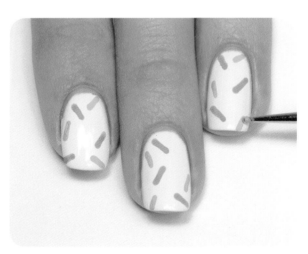

3 Apply another set of thin lines using orange acrylic paint.

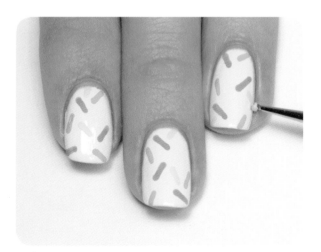

4 Apply a third set of lines using yellow acrylic paint.

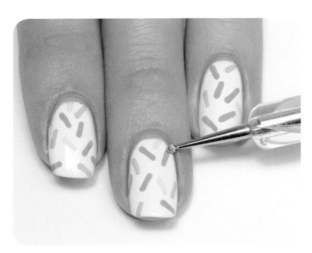

5 Continue to apply lines using green acrylic paint.

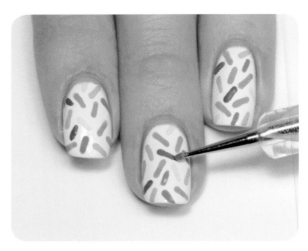

6 Complete the last two sets of lines using aqua and purple acrylic paint.

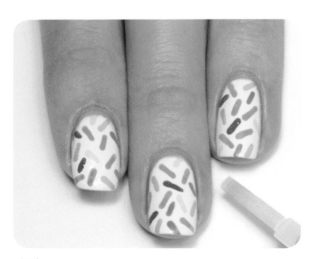

7 Finish with a top coat to seal the design and protect your manicure.

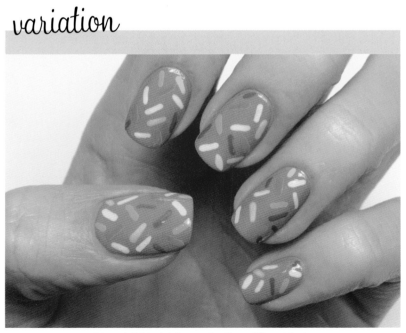

Try adding this design to just one nail as an accent.

Use a bright pink base color for a different look.

DIY Decals

Making your own nail decals is easier than ever! Simply use different shapes and colors to get a wide variety of looks.

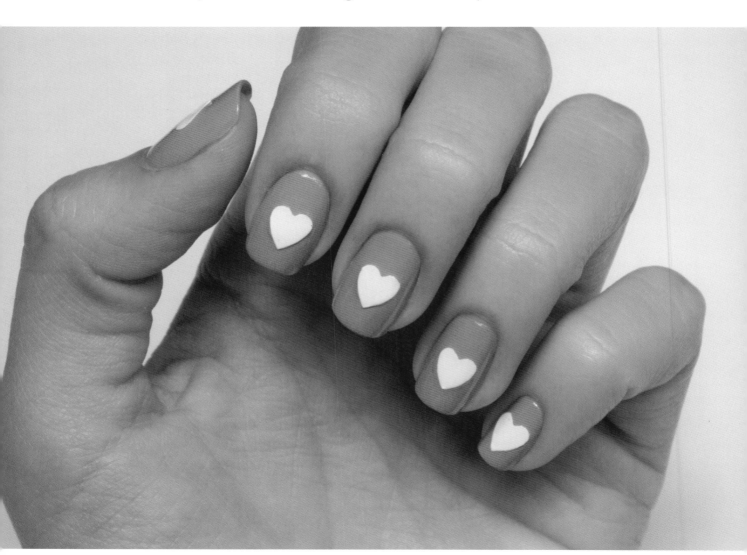

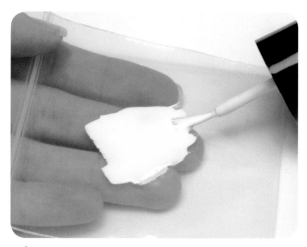

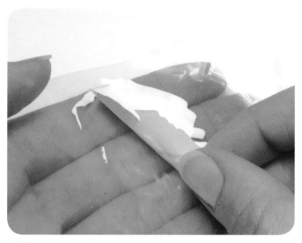

1 Apply two coats of polish to a small plastic bag. Let it dry for at least two hours. If you want to be safe, let it dry overnight.

2 Once it is completely dry, carefully peel off the nail polish.

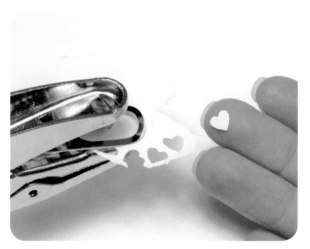

3 Create hearts by using a heart-shaped hand punch. The best sizes to fit on the nail are ¼" (6mm) and ³⁄₁₆" (5mm).

4 After you have punched out all of your shapes, apply a hot pink polish to the nail.

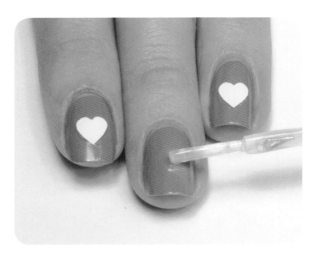 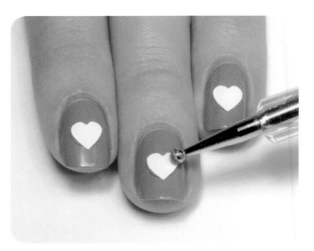

5 Apply a dab of top coat to the place you would like to apply your hearts.

6 Use a dotting tool dabbed with water to pick up each decal. Then place it on the top coat to stick onto the nail.

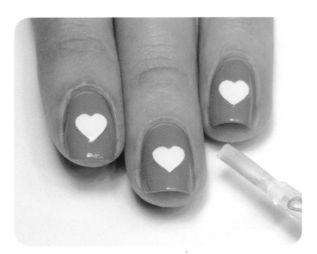

7 Finish with a top coat to seal in the design and protect your manicure.

toes, too!

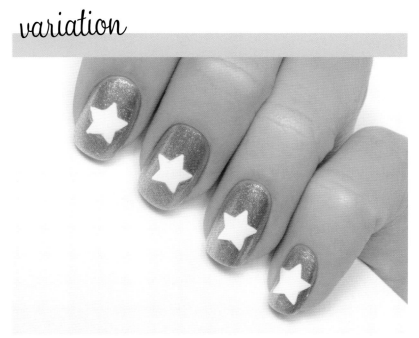

Apply decals to your toes for a fun pedicure.

variation

Another unique design uses star shapes and gold polish for the base color.

sponged and taped nail art

Now that you've mastered the dotting tool, you're ready to give these more advanced techniques a try. The effects that sponging and taping produce are amazing! You'll come back to both of these techniques time and again.

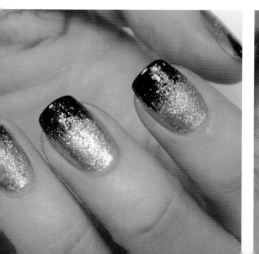

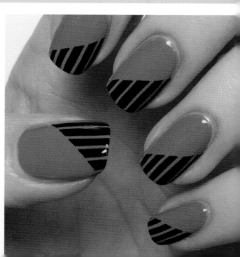

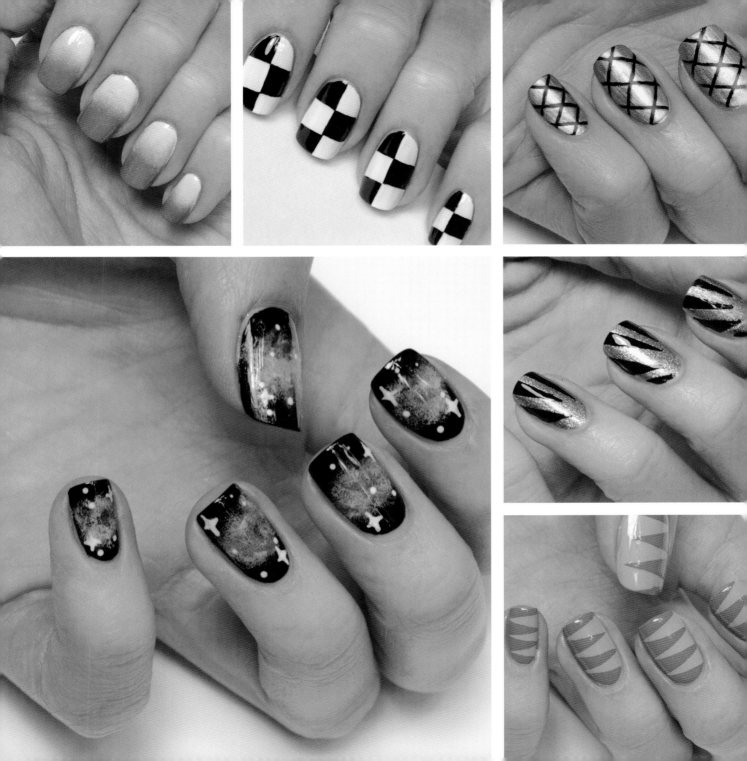

Glitter Gradients

These gorgeous glitter gradient nails are sure to turn heads!

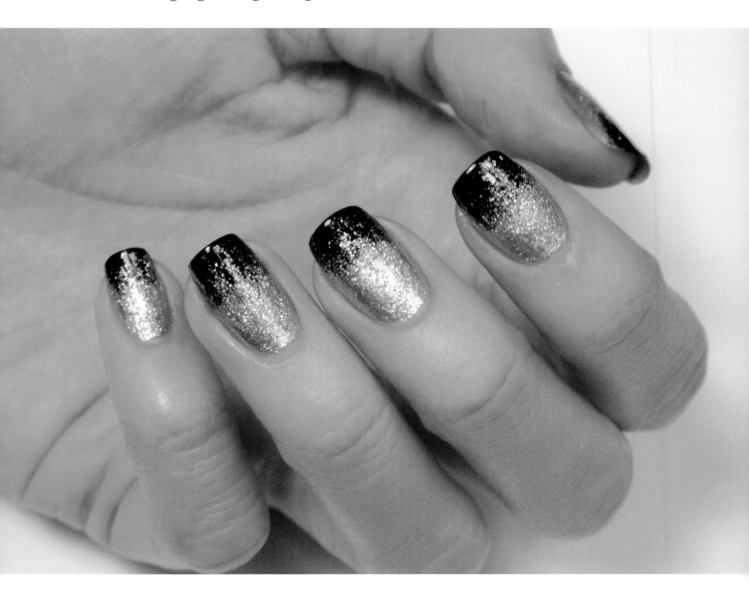

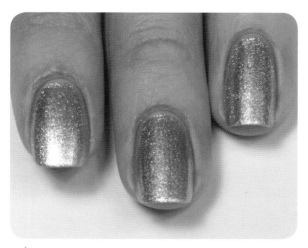

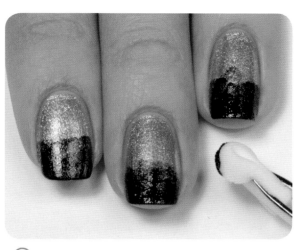

1 After your base coat has dried, paint your nails using a gold polish.

2 Use a small piece of a makeup sponge and tweezers to sponge black polish onto the tips of your nails.

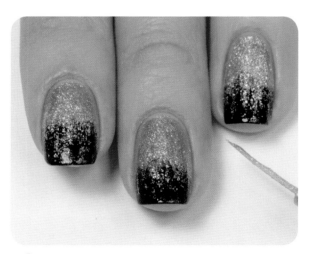

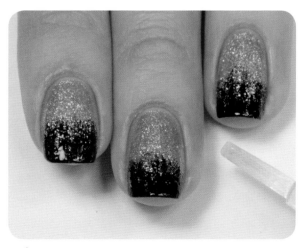

3 With a gold glitter striper, blend the two colors by applying small vertical lines between them. Then apply the gold glitter to the gold portion of the nail to match.

4 Finish with a top coat to seal the design and protect your manicure.

Distant Galaxies

This beautiful cosmic design is incredibly easy and looks out of this world!

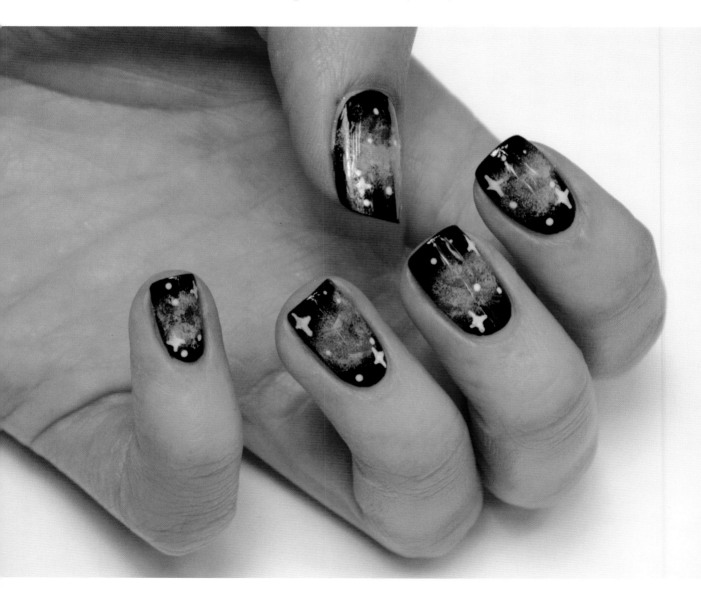

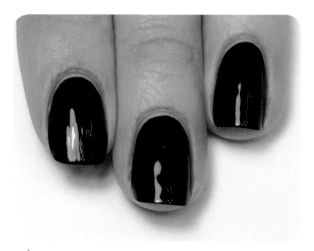

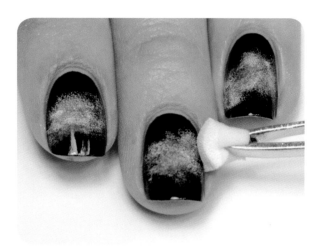

1 After your base coat has dried, paint your nails using a black polish.

2 Use a small piece of a makeup sponge and tweezers to lightly sponge white acrylic paint on the center of the nail.

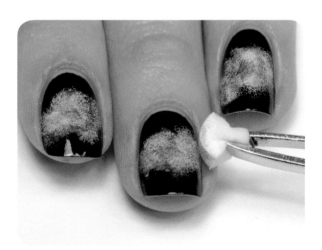

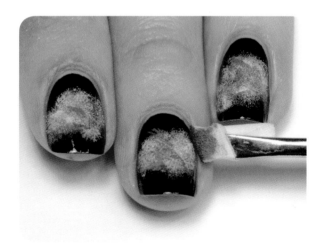

3 With the same tools and technique, sponge pink acrylic paint onto the center of the nail.

4 Sponge the last colors of purple and aqua onto the center of the nail.

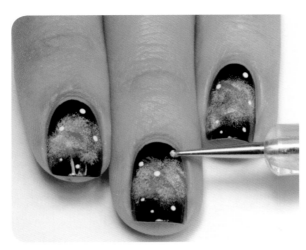

5 Use a small dotting tool to apply random small dots with white acrylic paint.

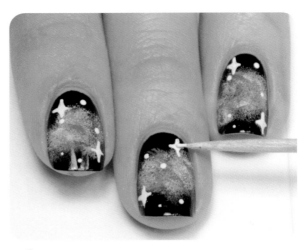

6 With a toothpick and white acrylic paint, carefully apply two intersecting lines to form each star shape.

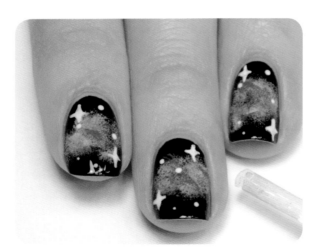

7 Finish with a top coat to seal the design and protect your manicure.

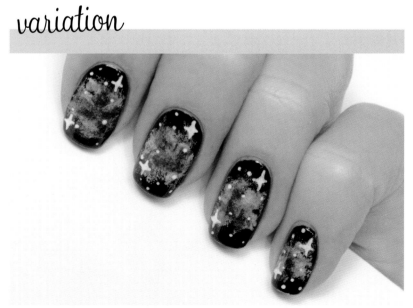

Make a glittery version of this design by painting your nails with glitter polish and using the galaxy on an accent nail.

Create different colored galaxy prints by using multiple shades of blue.

Subtle Ombre

This simple ombre design is striking and diverse.
Think of all the different color combinations you can try.

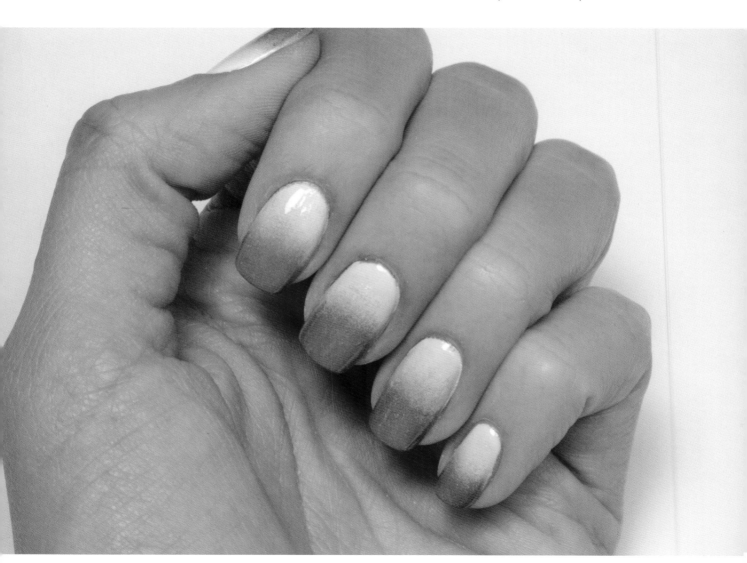

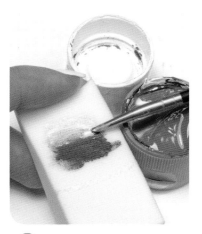

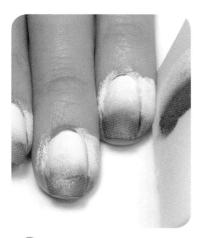

1 After your base coat has dried, paint your nails using white polish.

2 Using a small brush, paint white and purple acrylic paint onto a makeup sponge and slightly blend the two.

3 Lightly sponge one layer of the acrylic paint onto the nail.

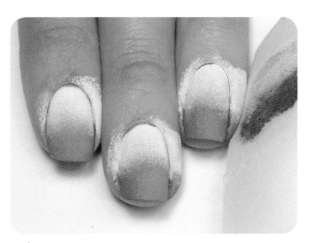

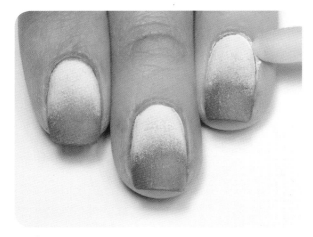

4 Wait for the previous layer to dry, then lightly sponge a second layer onto the nail until the ombre effect is complete.

5 Using a cotton swab dipped in nail polish remover, clean up any excess paint that has gotten onto your fingers. Finish with a top coat to seal the design and protect your manicure.

Fancy Fishnets

This subtle fishnet design is great for beginners because it's so simple!

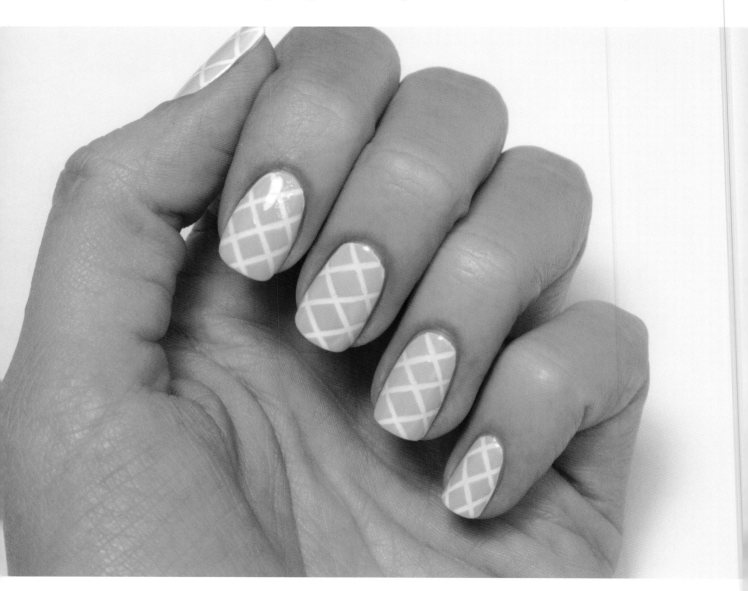

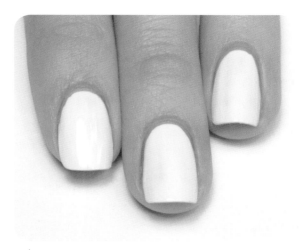

1 After your base coat has dried, paint your nails using a white polish.

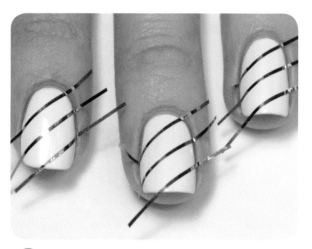

2 Place three strips of striping tape diagonally onto each nail.

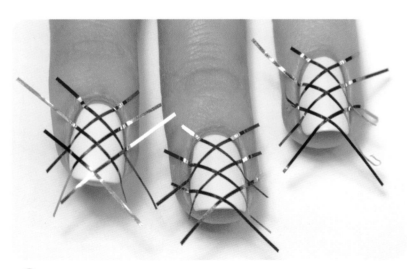

3 Place another three strips of striping tape going diagonally in the opposite direction to create the fishnet pattern.

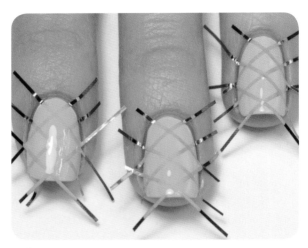

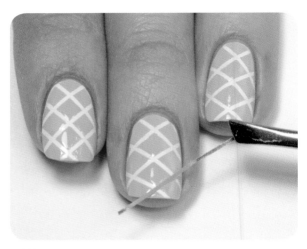

4 Apply a mint green polish over the nail and the tape.

5 With tweezers, carefully remove the strips of tape. It's crucial that you remove the tape while the polish is still wet. Doing so will ensure clean lines.

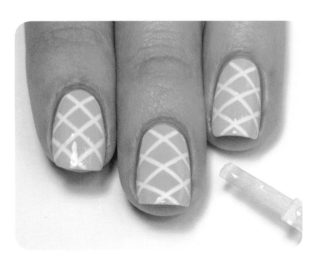

6 Finish with a top coat to seal in the design and protect your manicure.

toes, too!

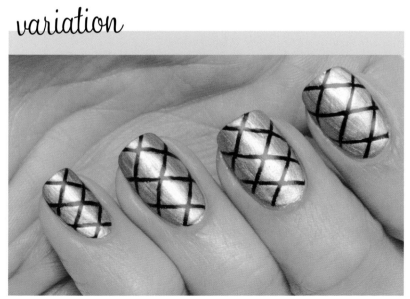

This design is just as easy to apply to your toes.

variation

*Change up the colors for a different look. Use black polish
for the base color and metallic pink polish on top.*

Intense Zigzags

With this design, your nails will be eye-catching and fabulous!

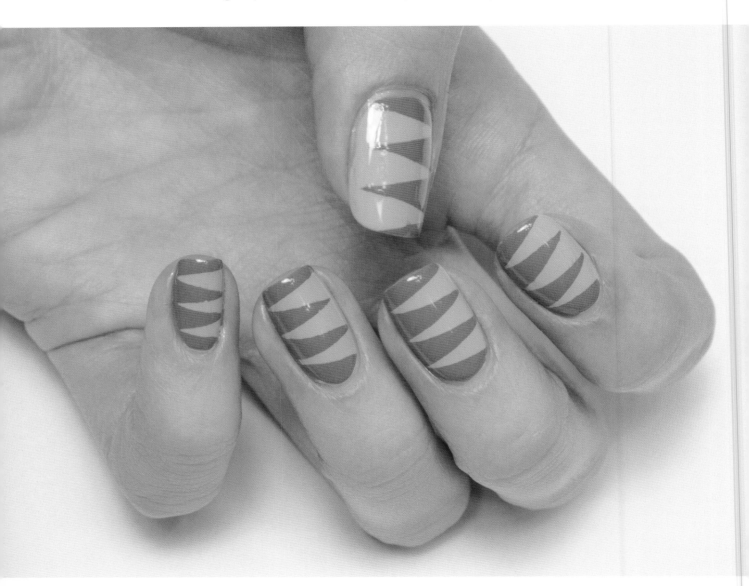

1 After your base coat has dried, paint your nails using mint-colored polish.

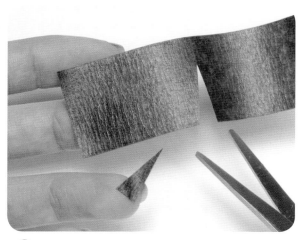

2 Once your polish has dried, cut three thin triangle shapes from painter's tape for each nail.

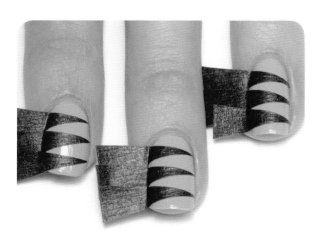

3 Apply the pieces of tape in a row down the nail.

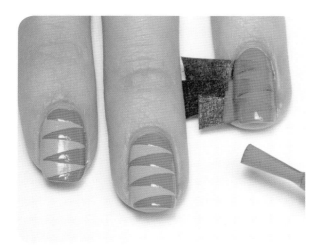

4 Use a bright pink polish to apply one coat over the entire nail.

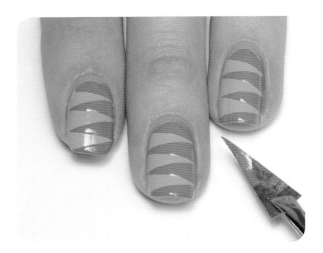

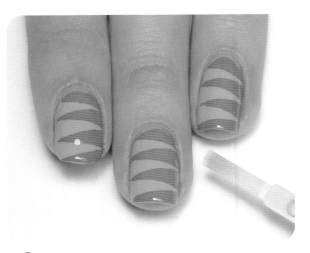

5 Remove the tape slowly while the polish is still wet. Doing so ensures clean lines.

6 Finish with a top coat to seal the design and protect your manicure.

variation

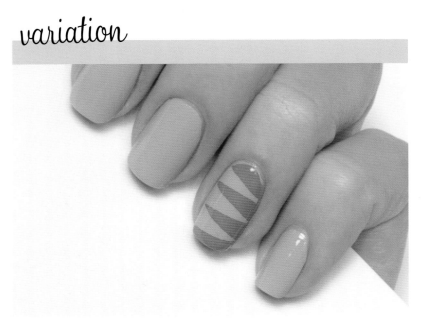

Add a unique touch with an accent nail!

variation

Switch up the colors for a fancier look!
Also, make your zigzags wider by using only two pieces of tape.

Cheeky Checkerboards

A simple yet stylish checkerboard design is always a fun idea.

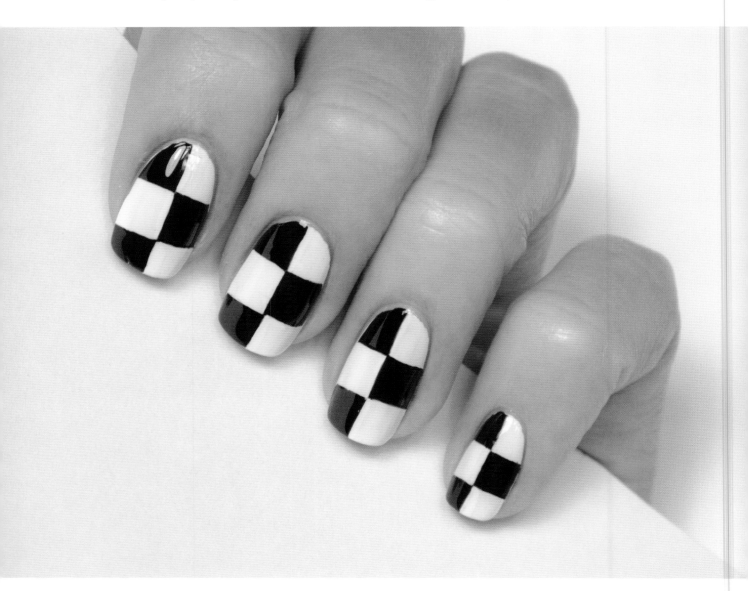

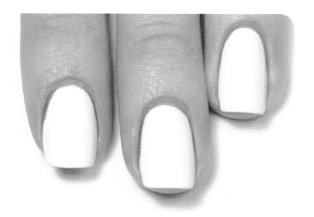

1 After your base coat has dried, paint your nails using white polish.

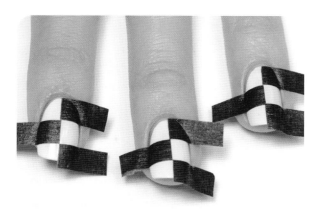

2 Cut three pieces of painter's tape to the same width. Place one piece of tape at the top of the nail with the left edge in the center of the nail. Place the second piece of tape directly below the first but with the right edge in the center of the nail. Place the third piece of tape below the second but with the left edge in the center, just like the first piece of tape.

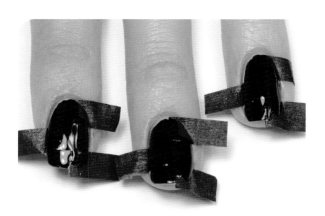

3 Apply black polish over the nail and the tape.

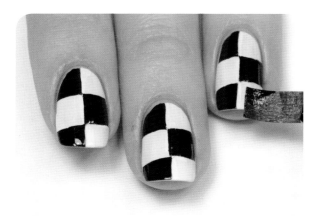

4 Use tweezers to carefully remove the tape while the polish is still wet. Doing so ensures clean lines. Finish with a top coat to seal the design and protect your manicure.

Glitter Rays

It's a sunburst of glitter! These nails will wow
at festive occasions like prom or New Year's Eve.

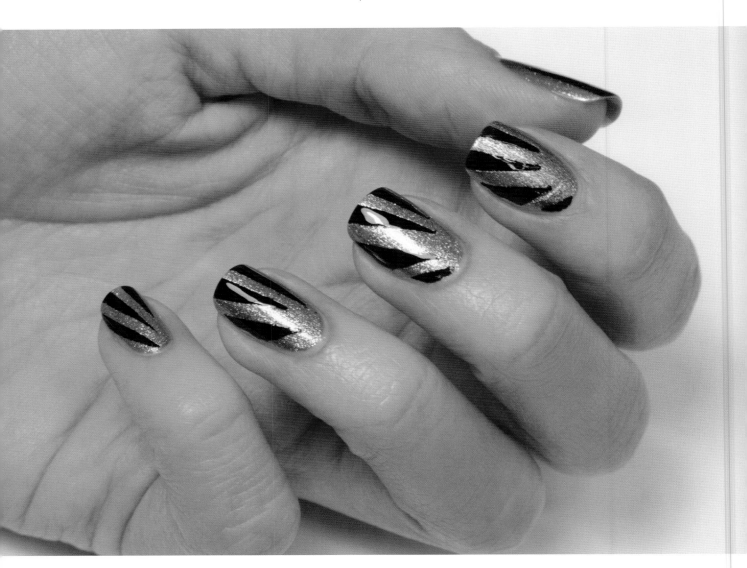

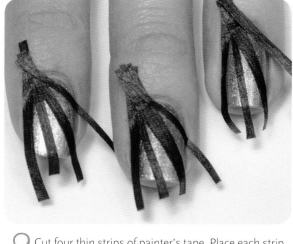

1 After your base coat has dried, paint your nails using gold polish.

2 Cut four thin strips of painter's tape. Place each strip coming from the upper corner of the nail. Make sure to place them so that sections of gold are still showing.

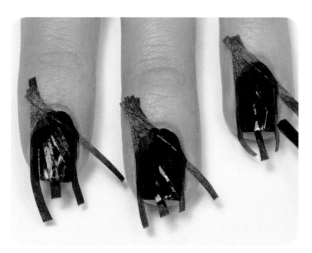

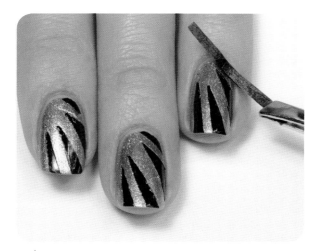

3 Apply black polish onto the nail and tape.

4 Use tweezers to carefully remove each strip of tape while the polish is still wet. Doing so ensures clean lines. Finish with a top coat to seal the design and protect your manicure.

Elegant Pinstripes

This easy design is a great way to spice up your nails.

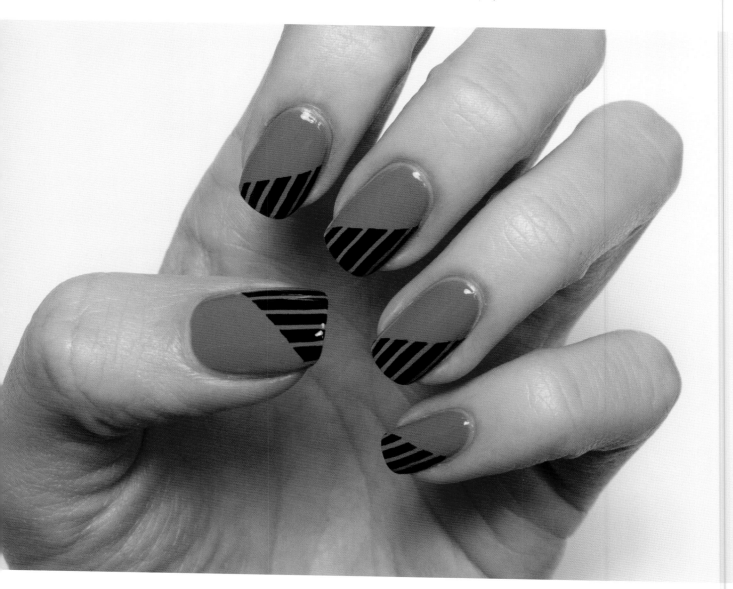

1 After your base coat has dried, paint your nails using brown polish.

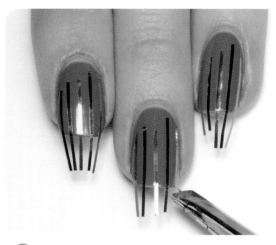

2 Apply multiple strips of striping tape going down the nail.

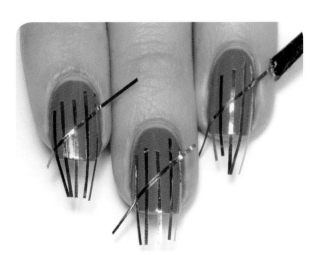

3 Apply another strip of tape diagonally across the nail over the previous strips.

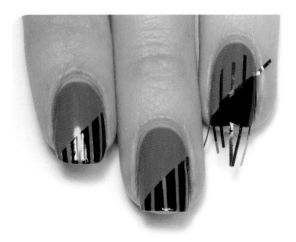

4 Using black polish, apply one coat over half of the nail, below the diagonal tape.

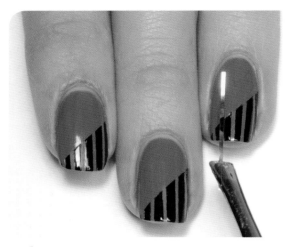

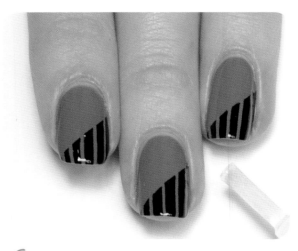

5 Remove the tape slowly while the polish is still wet to ensure clean lines.

6 Finish with a top coat to seal the design and protect your manicure.

variation

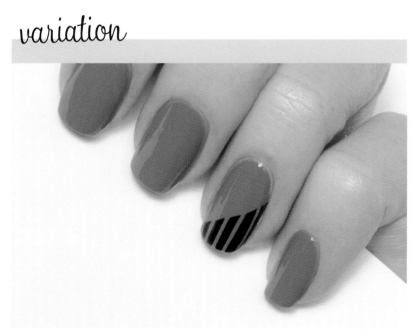

For an even more sophisticated look, apply pinstripes to only one nail.

variation

Try silver and white polish to create a glittery party design.

freestyle nail art

The world of nail art breaks wide open when you start freestyling your designs. Use stripers and toothpicks to draw pretty lace designs, cupcakes, skulls, bunnies and many more designs for holidays and every day. With a bit of practice, who knows where your imagination will take you?

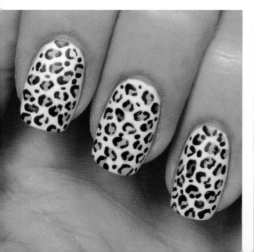
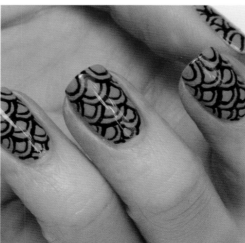
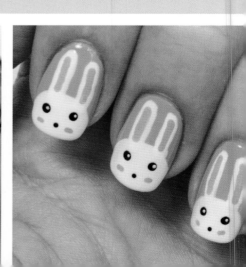

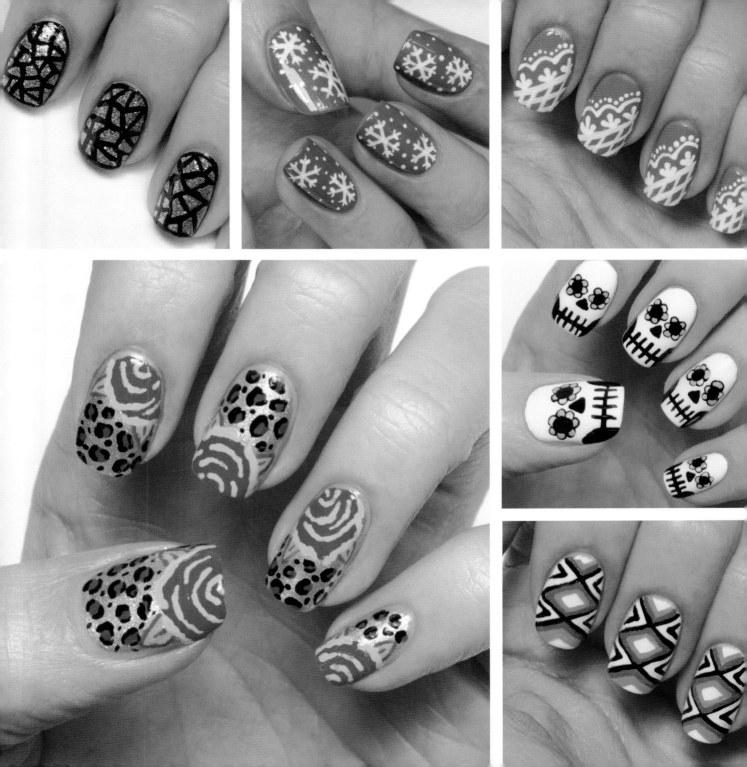

Cute Bows

This adorable bow design is fun, girly and easy!

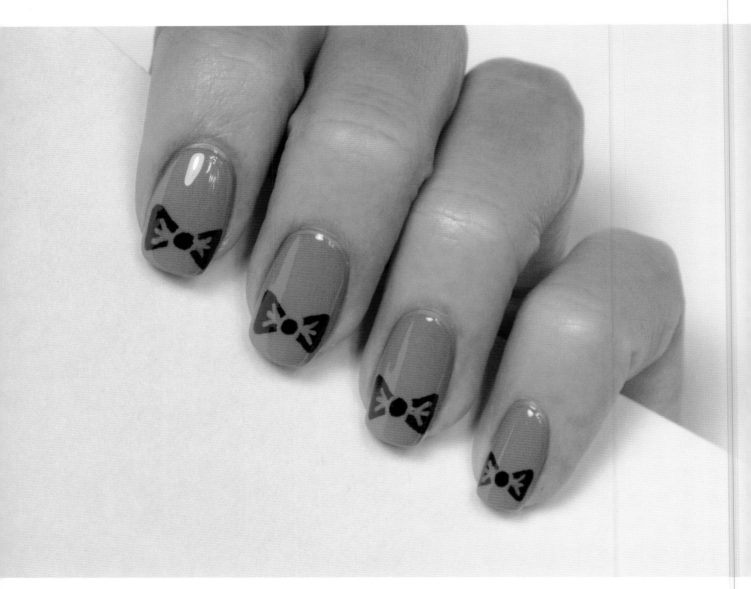

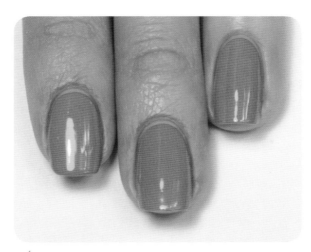

1 After your base coat has dried, paint your nails using pink polish.

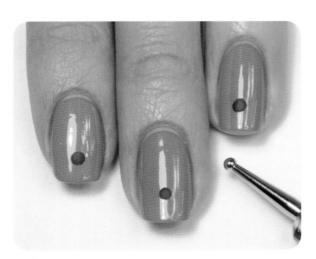

2 Use a medium dotting tool to apply a single dot of black acrylic paint to the center tip of the nail.

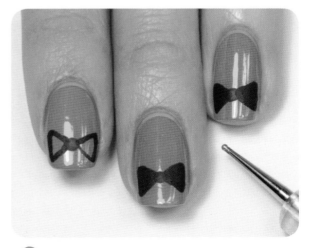

3 With a smaller dotting tool and black acrylic paint, create a triangle shape on each side of the dot and connect them to the dot. Then fill in the shapes.

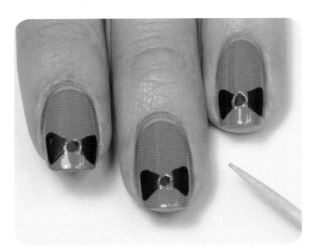

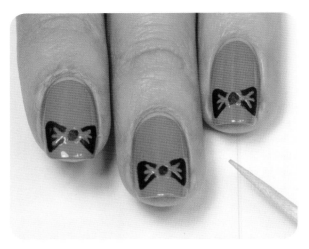

4 Using a toothpick, outline the middle dot with the same pink polish you used to paint your nails.

5 With the same toothpick and polish, apply three small lines coming from each side of the previous outline to form the folds of the bow.

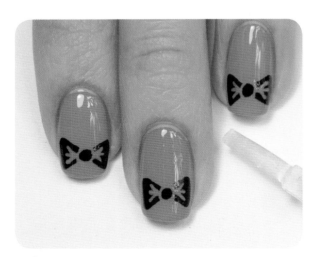

6 Finish with a top coat to seal the design and protect your manicure.

toes, too!

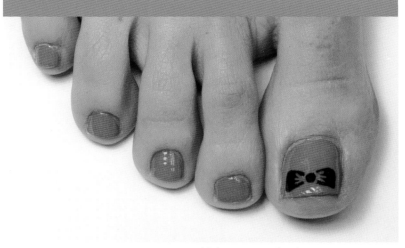

Fancy up your toes with just one cute bow!

variation

*For a dramatic change, use mint-colored polish
for the base color and add a single bow.*

Pretty Lace

These lovely lace nails are a perfect match for weddings or parties.

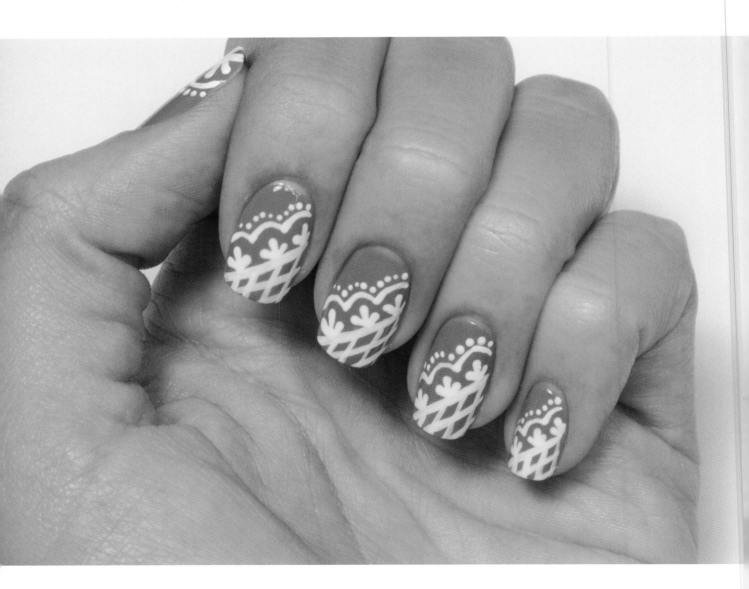

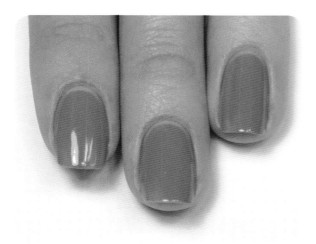

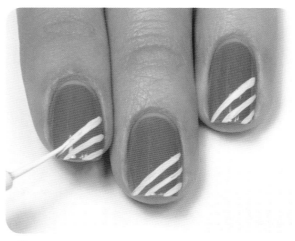

1 After your base coat has dried, paint your nails using light purple polish.

2 With a white striper, apply three stripes diagonally at the bottom of the nail.

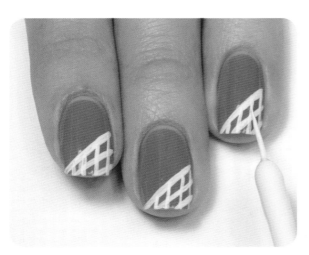

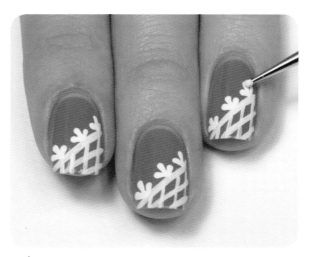

3 With the same striper, apply four vertical lines over the diagonal stripes.

4 Using a small dotting tool and white acrylic paint, apply three clusters of small lines to further the lace pattern.

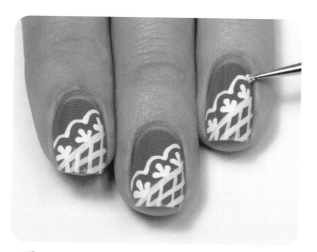 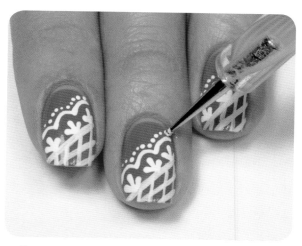

5 With the same tools, glide the acrylic paint in a curved line over the clusters.

6 Apply small dots along the curved line you just made.

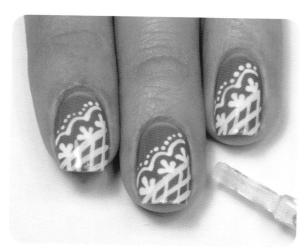

7 Finish with a top coat to seal the design and protect your manicure.

variation

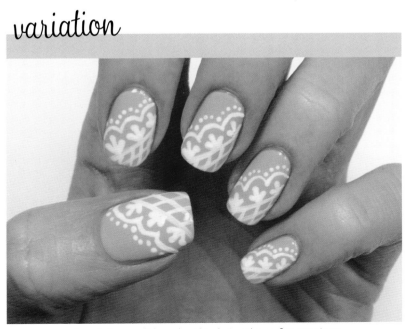

Add an elegant touch to your ring finger using lace on an accent nail.

variation

*A nude base polish makes this design the perfect manicure
for weddings and other formal occasions.*

Yummy Cupcakes

If you have a sweet tooth, this adorable cupcake design is perfect for you.

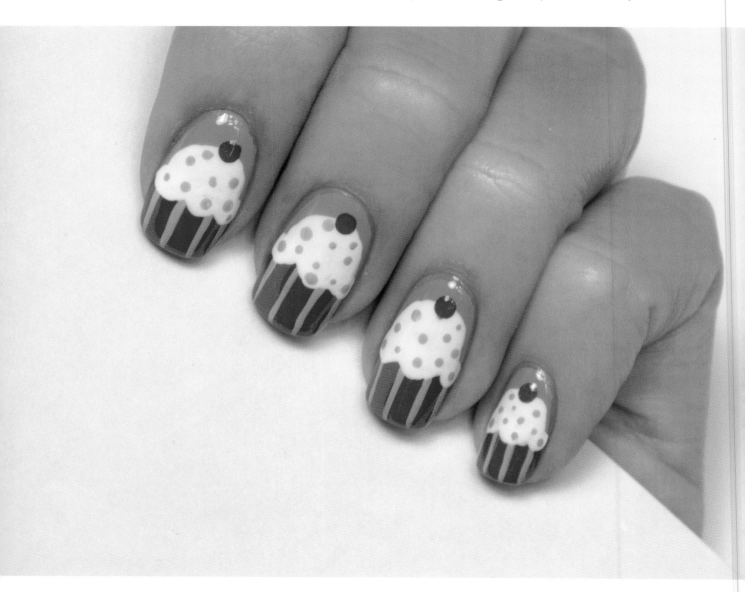

1 After your base coat has dried, paint your nails using light blue polish.

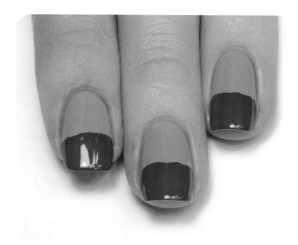

2 Apply dark pink polish to approximately half of your nail.

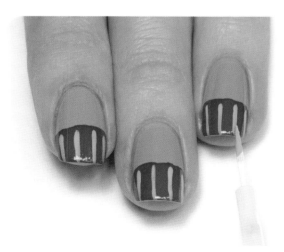

3 Using a striping brush and light pink polish, paint four stripes over the dark pink polish.

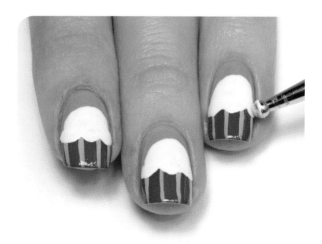

4 With a larger dotting tool, apply white polish in a circular motion over the top of the previous polishes to create the cupcake top. Carefully glide the polish to fill in this area.

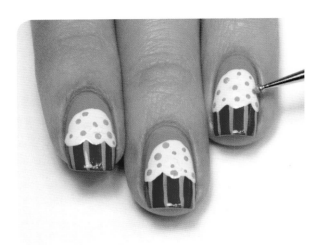

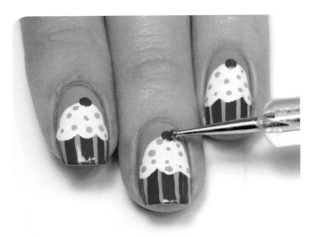

5 Use a smaller dotting tool and the light pink polish to apply dots to the white area. These are your sprinkles.

6 With the smaller dotting tool and the dark pink polish, apply a single larger dot at the top of the cupcake for the cherry.

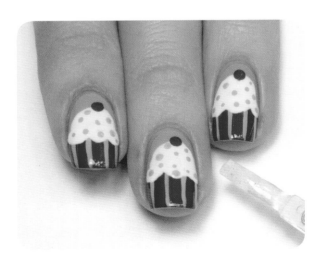

7 Finish with a top coat to seal the design and protect your manicure.

variation

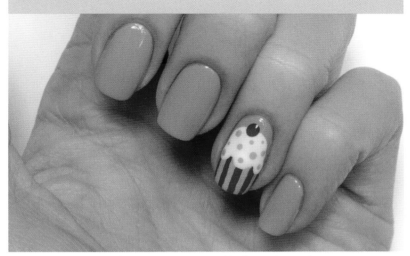

This sweet design as an accent nail looks good enough to eat.

toes, too!

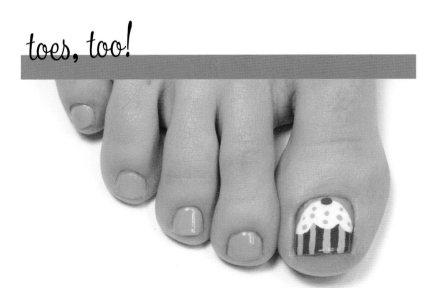

Add this design to your big toe for the cutest pedicure.

Shattered Pieces

This design is gorgeous and eye-catching. It's a definite conversation starter!

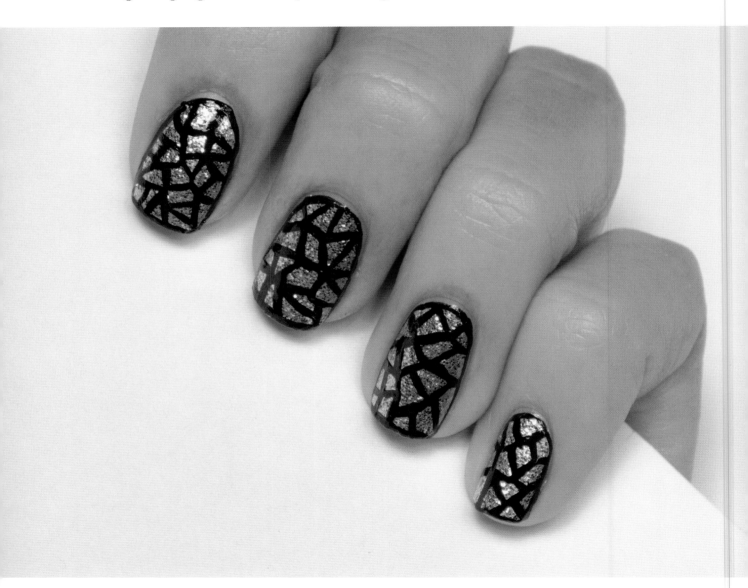

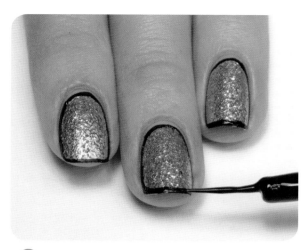

1 After your base coat has dried, paint your nails using gold polish.

2 Use a black striper to outline the entire nail.

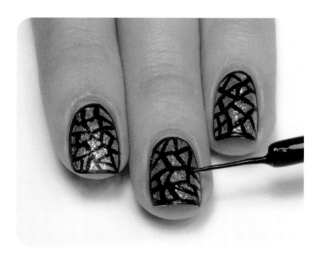

3 With the same striper, carefully apply random connecting lines to form the shattered look. Finish with a top coat to seal the design and protect your manicure.

toes, too!

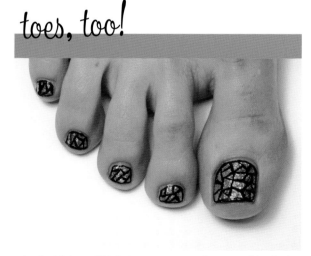

Apply this beautiful design to your toes for a matching look.

Abstract Leaves

This abstract design is easy to create
and perfect to wear during the autumn months.

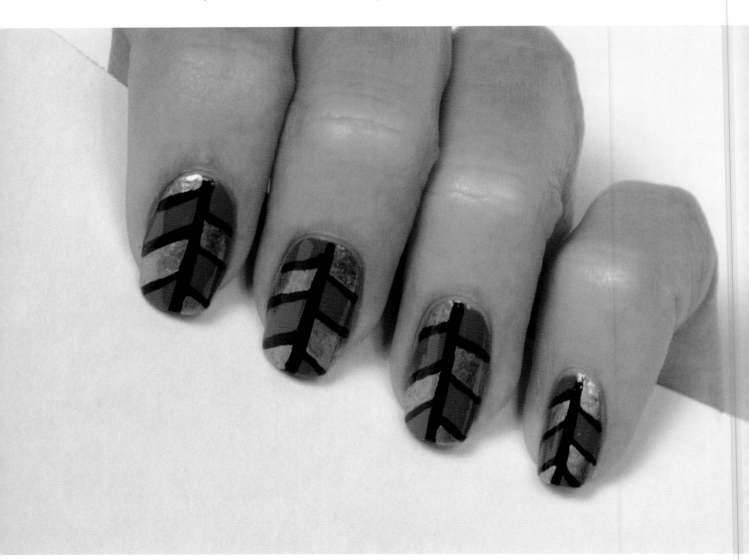

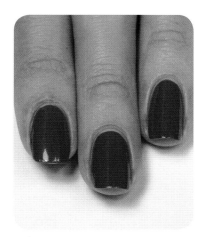 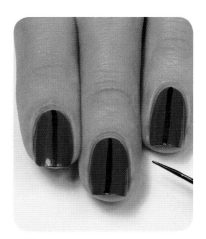 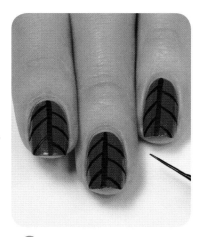

1 After your base coat has dried, paint your nails using wine-colored polish.

2 Use a black striper to apply a straight line down the middle of the nail.

3 With the same black striper, apply diagonal lines on each side of the previous line you created. Make sure they don't line up with each other exactly.

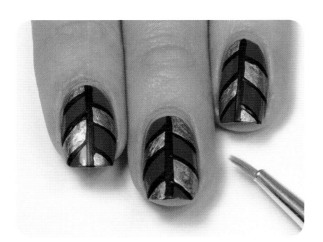 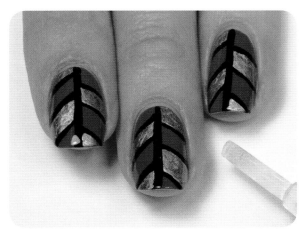

4 With a small brush, fill in every other space using metallic light green polish.

5 Finish with a top coat to seal the design and protect your manicure.

Colorful Cheetahs

Take a ride on the wild side with these colorful cheetah-print nails!

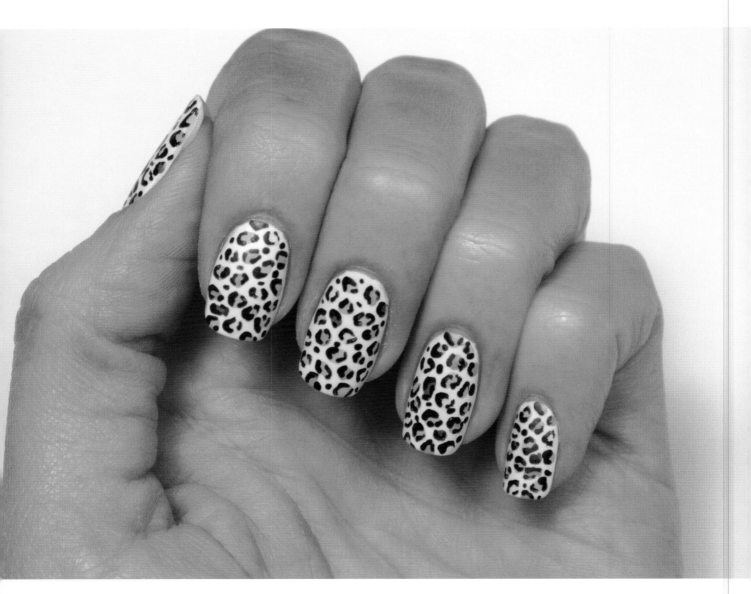

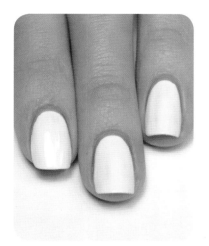

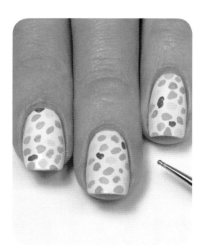

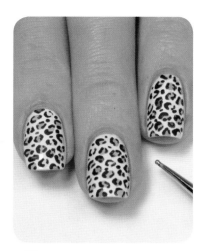

1 After your base coat has dried, paint your nails using white polish.

2 Use a small dotting tool to apply random, irregular spots across the whole nail with a variety of acrylic paints (here I've used light pink, pink, purple, blue, orange and green).

3 With the same dotting tool, apply partial outlines to each spot with black acrylic paint. Also apply small black dots to fill in any empty areas.

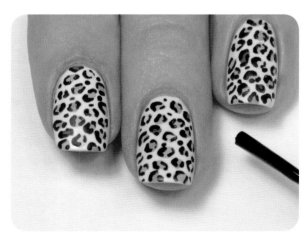

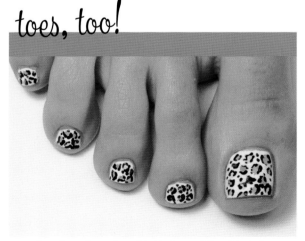

toes, too!

4 Finish with a top coat to seal the design and protect your manicure.

Literally walk on the wild side by applying this design to your toes.

Neon Scales

Want a twist in your typical fish scale design? Try these neon scale nails!

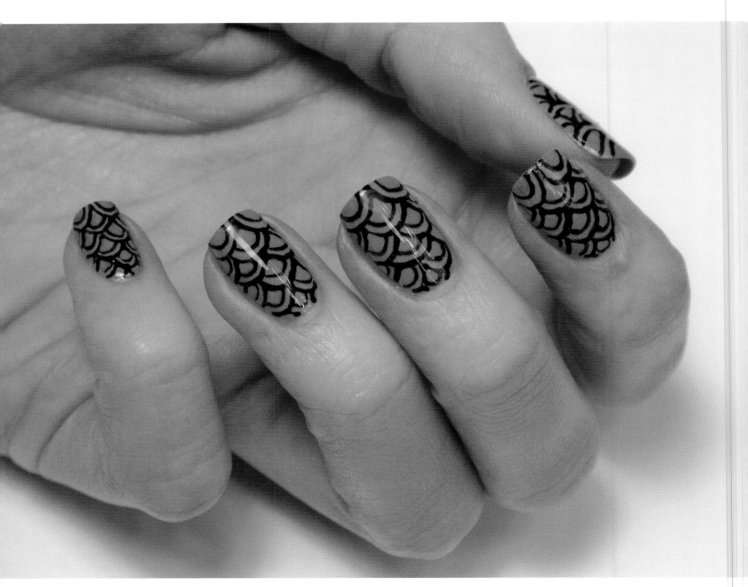

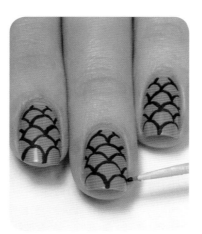

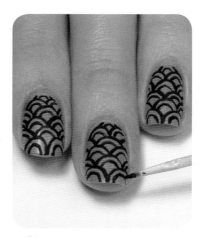

1 After your base coat has dried, paint your nails using hot pink polish.

2 Use a toothpick and black acrylic paint to create scales going up the nail from the tip.

3 With the same tools, apply another set of scales within the first set.

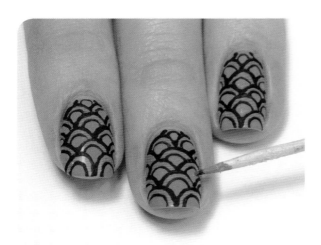

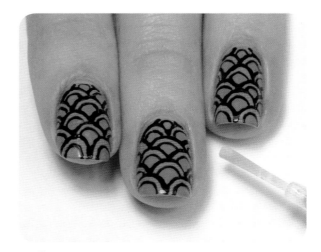

4 With a toothpick and aqua acrylic paint, fill in the larger part of each scale.

5 Finish with a top coat to seal the design and protect your manicure.

Stained Glass

Inspired by beautiful stained glass art,
these nails are stunning and won't go unnoticed!

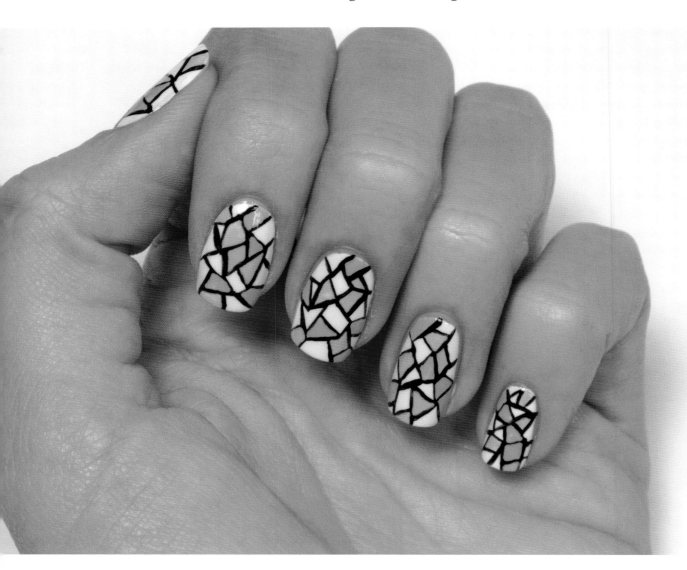

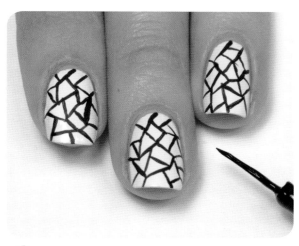

1 After your base coat has dried, paint your nails using white polish.

2 Using a black striper, create random connecting lines over the entire nail.

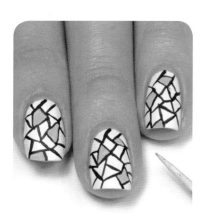

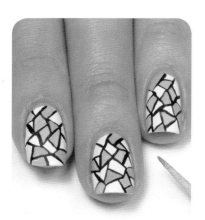

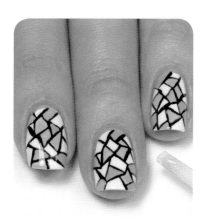

3 With a toothpick and pink acrylic paint, fill in a few random pieces.

4 Continue to fill in other pieces on the nail using blue, green and orange acrylic paint. Remember to leave some areas white.

5 Finish with a top coat to seal the design and protect your manicure.

Snazzy Skulls

Skulls aren't just for Halloween! This fashionable style
makes a cool statement anytime.

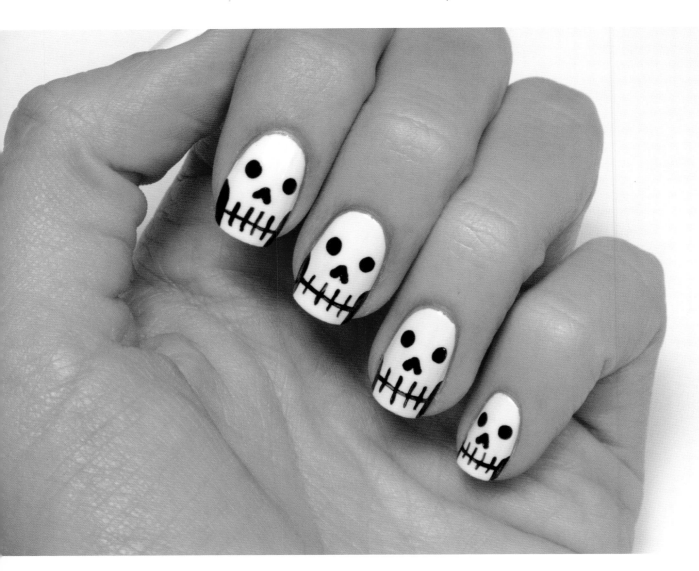

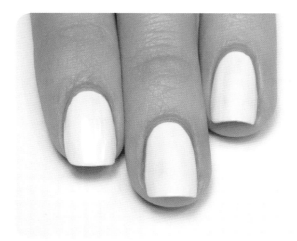

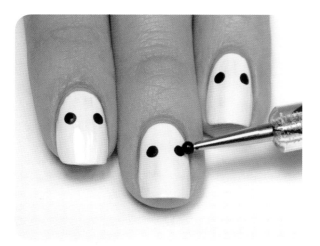

1 After your base coat has dried, paint your nails using white polish.

2 Use a medium dotting tool and black acrylic paint to apply two dots for the eyes.

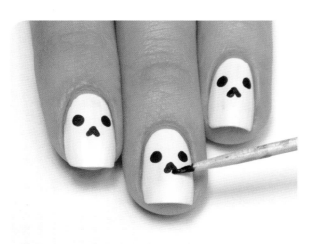

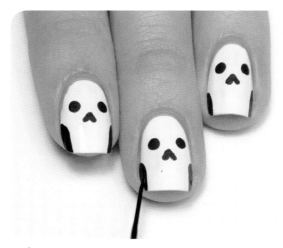

3 Use a toothpick and black acrylic paint to make an upside-down V shape for the nose.

4 With a black striper, mark an area on each side of the nail to form the shape of the skull.

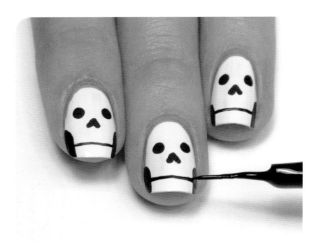

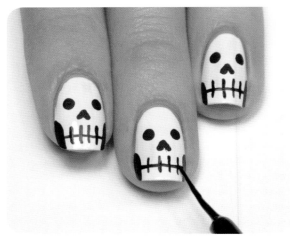

5 Use the same black striper to apply a straight line connecting the two black areas that were just created. This will form the mouth.

6 Apply four vertical lines across the horizontal mouth to create the teeth.

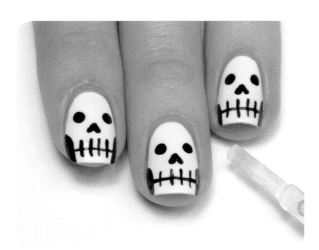

7 Finish with a top coat to seal the design and protect your manicure.

variation

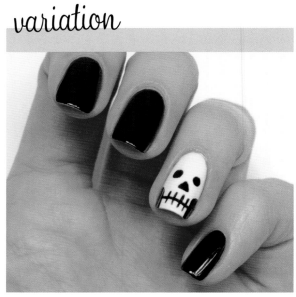

Create this design on a single nail for a rock 'n' roll touch!

variation

You can turn this design into the perfect Dia De Los Muertos skull! Simply apply black dots around the eyes, then apply colored dots on top. Leave some of the black visible to create an outline and form a flower shape.

Yin and Yang

The black and white contrast of these yin and yang nails
makes them a perfect match for many different outfits.

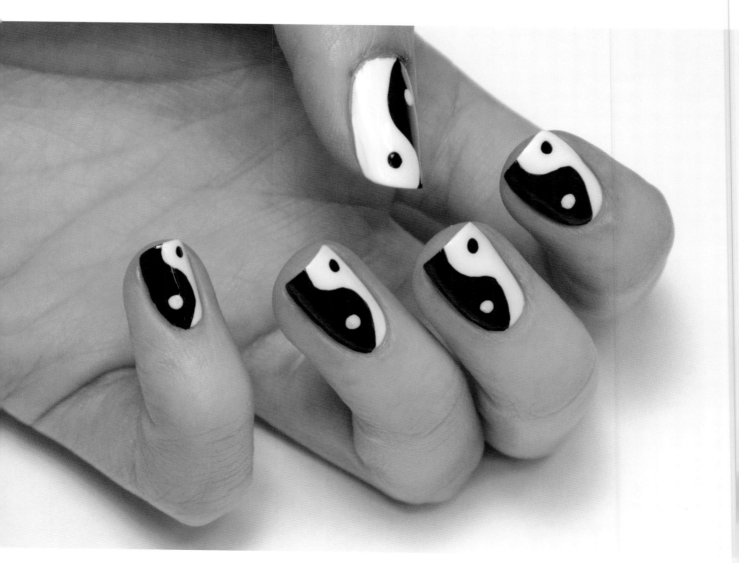

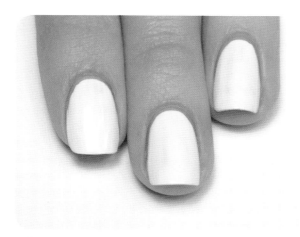

1 After your base coat has dried, paint your nails using white polish.

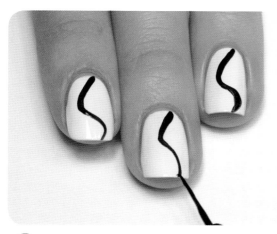

2 Using a black striper, draw an *S* shape down the middle of the nail.

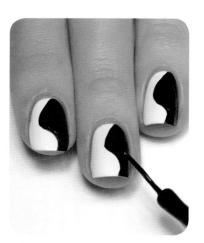

3 With the same black striper, fill in one side of the nail.

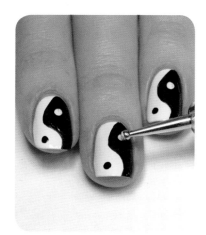

4 Use a medium dotting tool and acrylic paint to apply a white dot in the black area and a black dot in the white area. Place them so they are diagonal from one another.

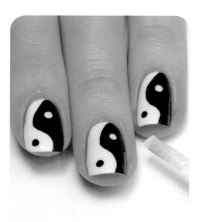

5 Finish with a top coat to seal the design and protect your manicure.

Tribal Print

This unique tribal design is vibrant and trendy!

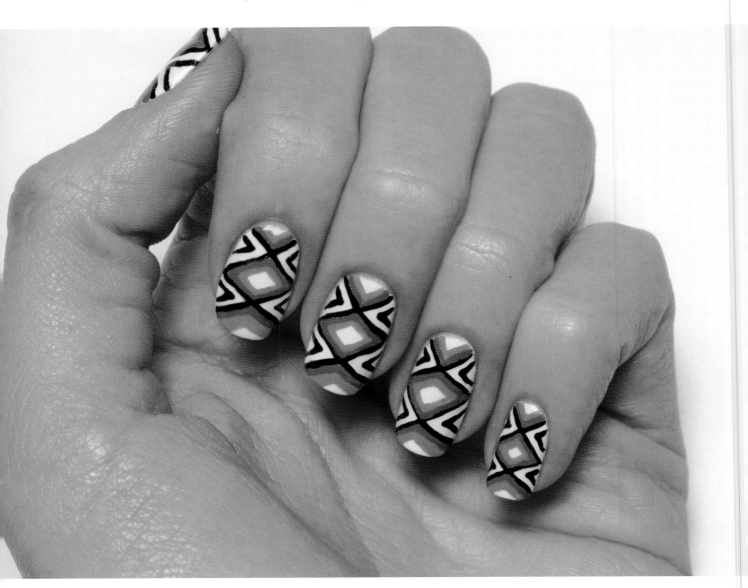

 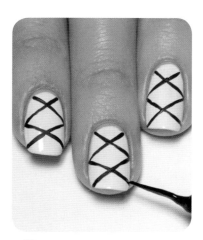 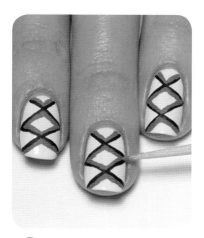

1 After your base coat has dried, paint your nails using white polish.

2 Use a black striper to draw two X shapes onto each nail.

3 Use a toothpick and purple acrylic paint to apply an outline to the middle area of each X.

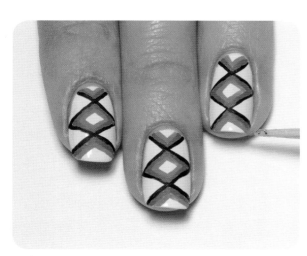 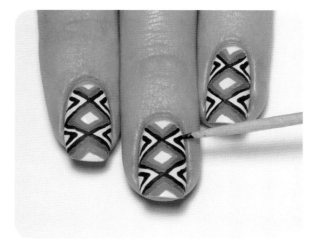

4 Use a toothpick and aqua acrylic paint to apply another set of outlines bordering the purple color.

5 With black acrylic paint, create small V shapes to fill in both sides of the nail. Finish with a top coat to seal the design and protect your manicure.

Leopard Rose

This design is the perfect blend of wild and feminine.

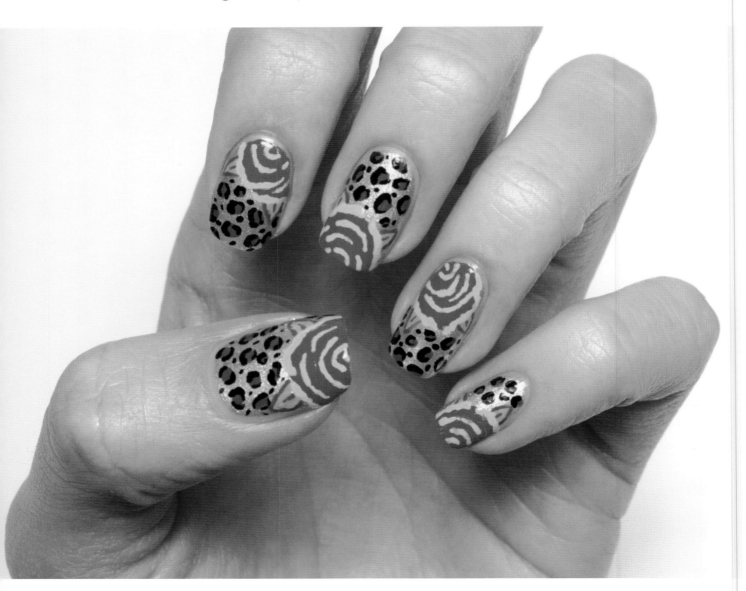

1 After your base coat has dried, paint your nails using gold polish.

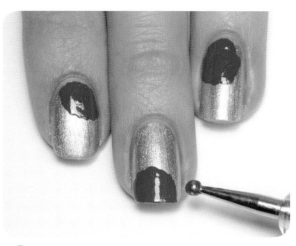

2 Use a deep pink color and a dotting tool to stipple a round area onto the nail that will become the base for the rose. Alternate the position from nail to nail.

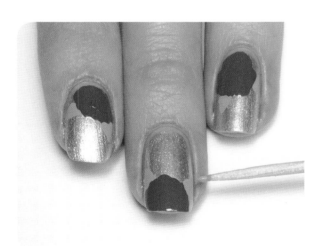

3 Use a toothpick and mint green acrylic paint to make two small leaves around the area of pink.

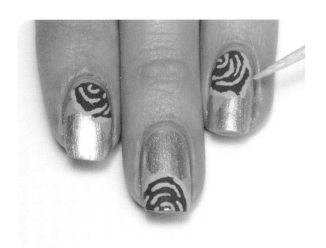

4 Use a toothpick and light pink acrylic paint to partially outline the rose. Then apply curved lines onto the deep pink area to form the look of petals.

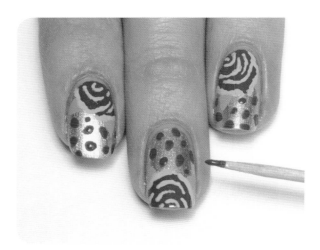

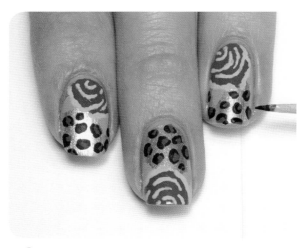

5 Use a toothpick and brown acrylic paint to apply spots onto the remaining gold polish.

6 Use black acrylic paint to partially outline the brown spots.

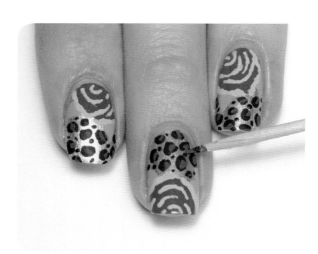

7 Use the same black paint and a toothpick to place random dots to fill in the rest of the print.

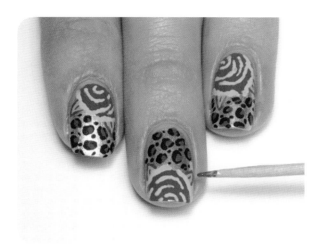 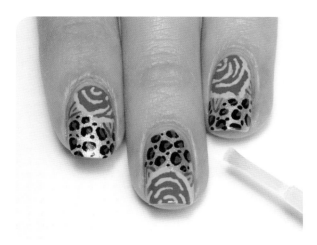

8 With a toothpick and darker green acrylic paint, outline the leaves and apply a small line in the middle of each leaf.

9 Finish with a top coat to seal the design and protect your manicure.

variation

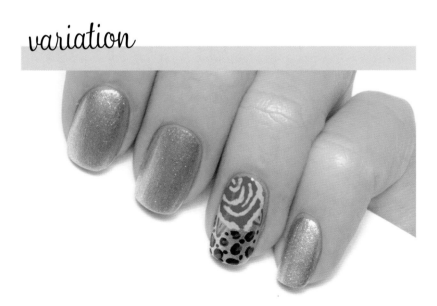

This design creates the perfect accent nail when paired with plain gold polish.

Valentine's Day

These Valentine's Day nails are full of hugs and kisses!

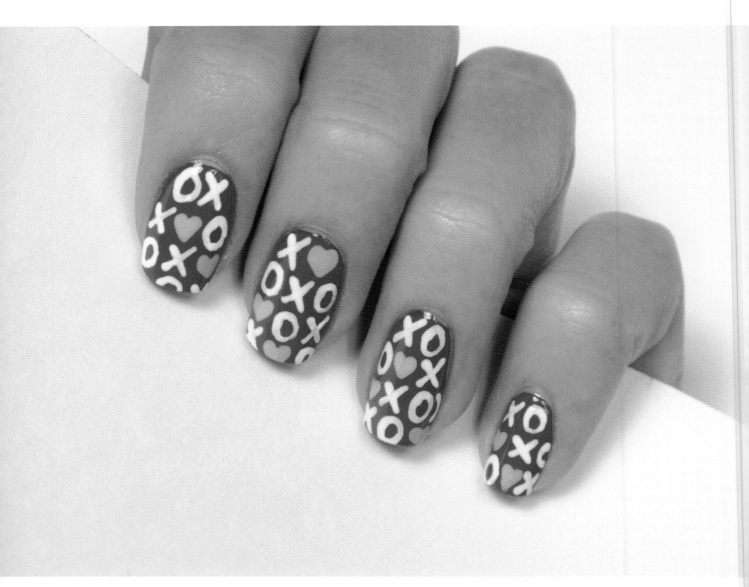

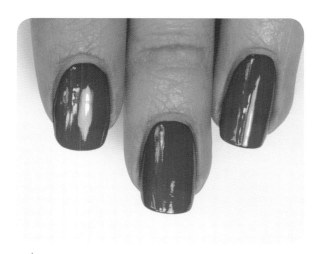

1 After your base coat has dried, paint your nails using red polish.

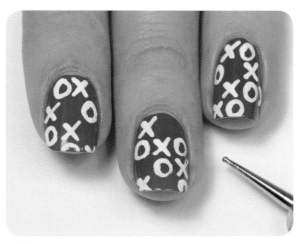

2 Use a small dotting tool and white acrylic paint to apply X and O shapes onto the nail. Be sure to leave some spaces open for the hearts.

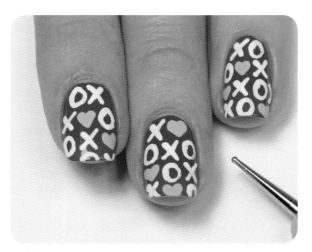

3 With a small dotting tool and pink acrylic paint, apply heart shapes in the open spaces.

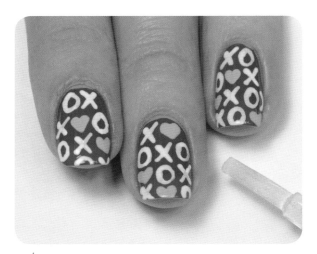

4 Finish with a top coat to seal the design and protect your manicure.

Easter Bunnies

These bunny nails are too cute! They're perfect for Easter or anytime you want to look at something adorable.

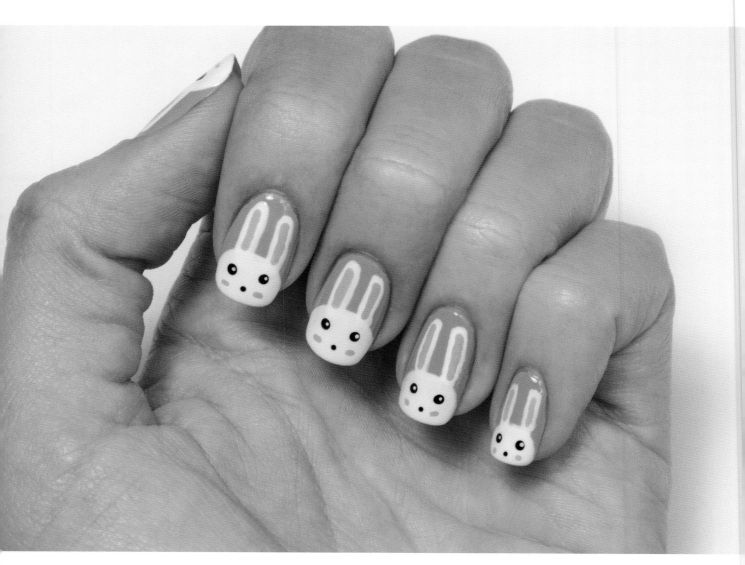

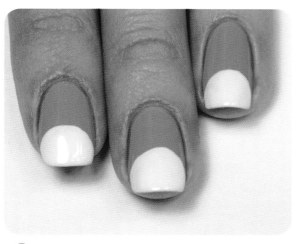

1 After your base coat has dried, paint your nails using light blue polish.

2 Apply a half-circle shape to the tip of the nail using white polish.

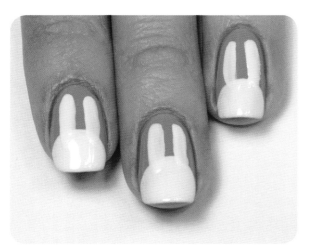

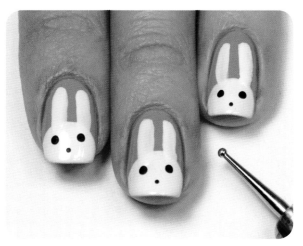

3 With the same white polish, brush down two thick lines and connect them with the half circle to create the ears.

4 Use a dotting tool and black acrylic paint to apply two dots for the eyes and a smaller dot for the nose.

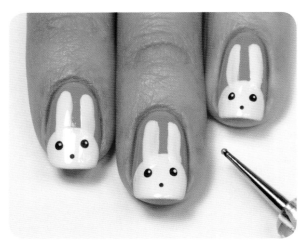

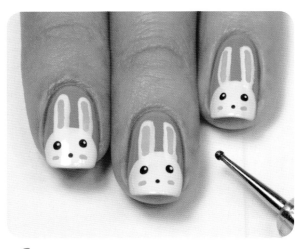

5 Use a smaller dotting tool to create tiny highlights in the eyes with white acrylic paint. Place one dot in the upper right of each eye.

6 With a small dotting tool, apply pink acrylic paint down the length of the ears and across the cheeks.

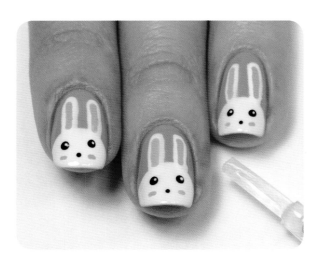

7 Finish with a top coat to seal the design and protect your manicure.

variation

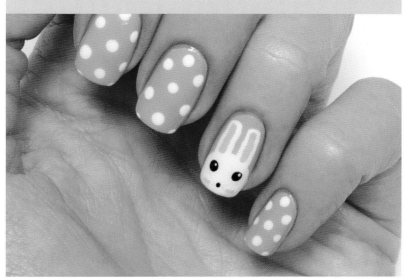

Matching this bunny accent with simple polka dots gives you a manicure too cute to ignore.

toes, too!

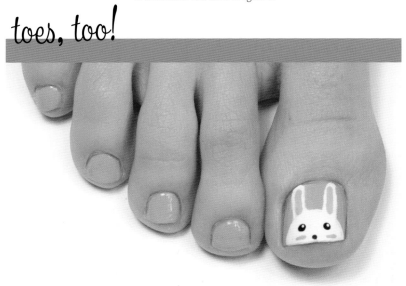

Add a bunny to your big toe for a cute surprise.

Birthday Cake

Have a birthday coming up?
These festive birthday cake nails are perfect for your special day.

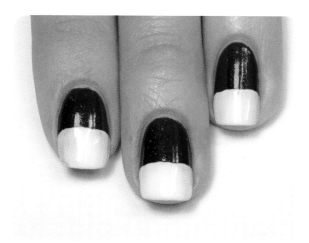

1 After your base coat has dried, paint your nails with shimmery deep purple polish.

2 Apply white polish to slightly less than half of your nail.

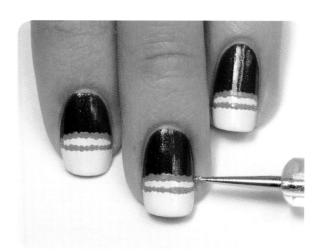

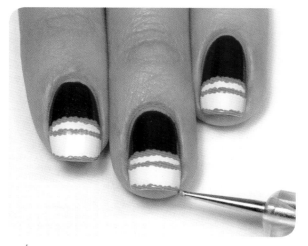

3 Use a small dotting tool and hot pink polish to apply tiny connecting dots in an oval shape onto the top part of the cake.

4 With the same dotting tool and polish, apply tiny connecting dots to the bottom of the cake.

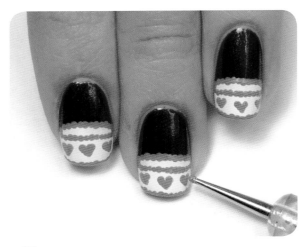

5 Using the same tools and polish, draw three small hearts in the middle of the cake.

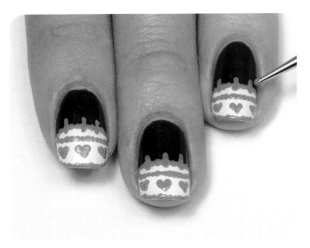

6 Use the small dotting tool and blue acrylic paint to make three small lines on the top of the cake. These will be the candles.

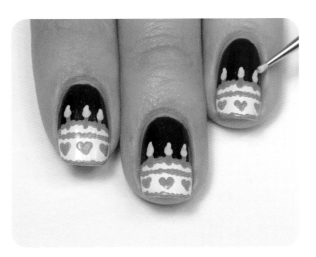

7 With the same dotting tool and yellow acrylic paint, add small teardrop shapes on the tops of the blue lines to finish the lit candles.

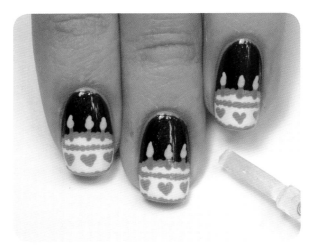

8 Finish with a top coat to seal the design and protect your manicure.

variation

Let everyone know it's your special day by painting one accent nail.

toes, too!

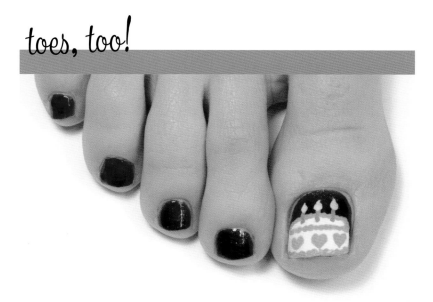

Birthday toes are fun, too! Do it yourself or ask a friend for help.

Spooky Spiderwebs

Need a festive yet simple Halloween design?
These spooky spiderweb nails are perfect for tricks or treats.

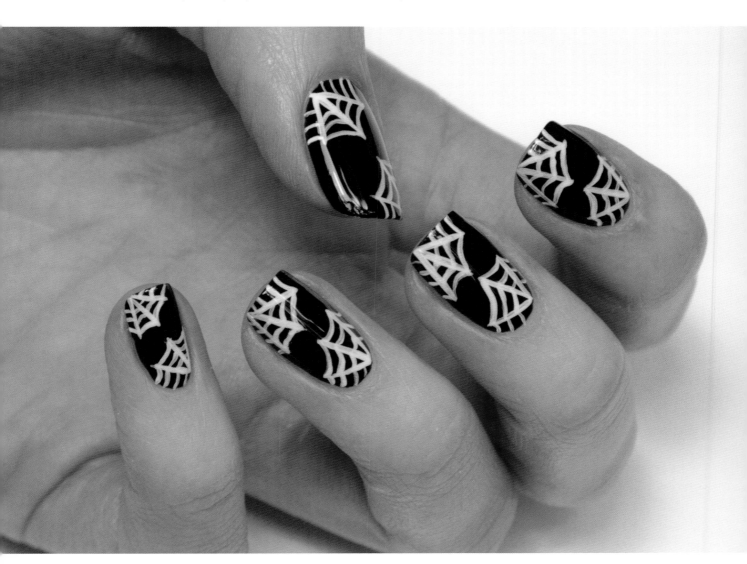

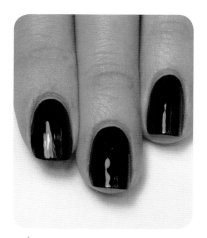

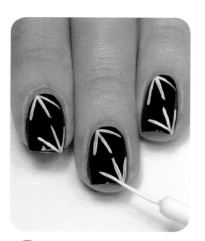

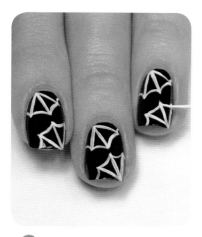

1 After your base coat has dried, paint your nails using black polish.

2 Use a white striper to apply three lines coming from one corner in an arrow formation. Paint another three lines coming from the opposite corner.

3 With a white striper, connect the lines by applying curved lines in between. Add curved lines to the edge of the nail, too.

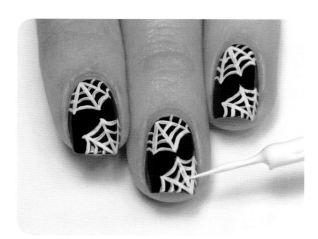

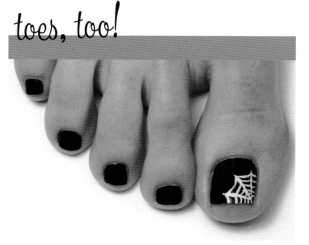

toes, too!

4 Continue to add curved lines to fill in the spiderwebs. Finish with a top coat to seal the design and protect your manicure.

Simplify the design for your toes by painting one web on an accent nail.

Frosty Snowflakes

These adorable snowflake nails are perfect for those chilly winter months.

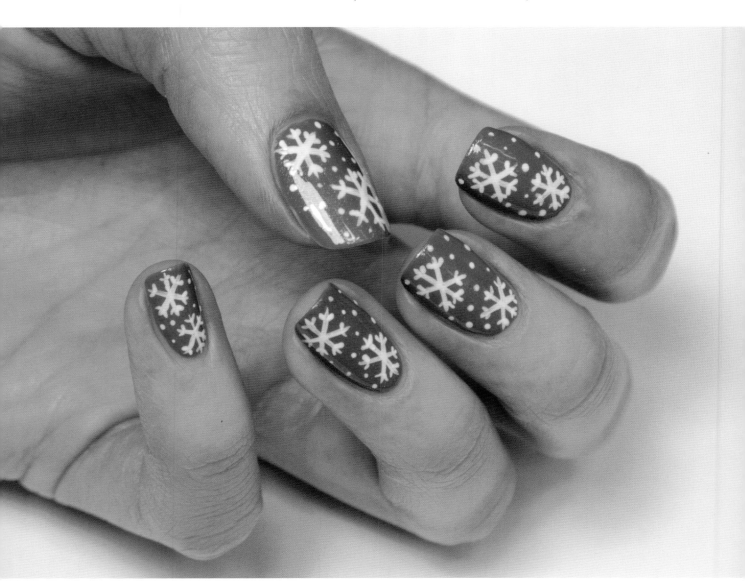

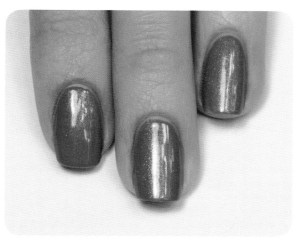

1 After your base coat has dried, paint your nails using blue polish.

2 Apply one layer of a sheer shimmer polish to add a glittery effect.

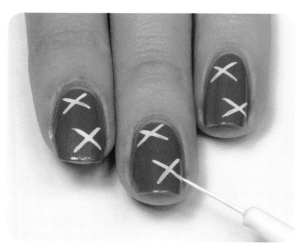

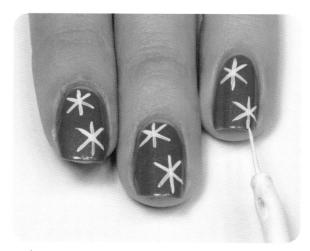

3 Use a white striper to apply two X shapes onto the nail.

4 With the same white striper, apply a straight line going down both X shapes.

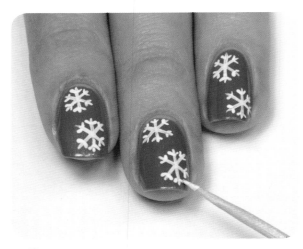

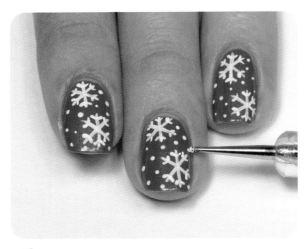

5 Use a toothpick and white acrylic paint to apply two small lines at the end of each line of the snowflake.

6 With a small dotting tool and white acrylic paint, apply random dots around the snowflakes to create the look of falling snow.

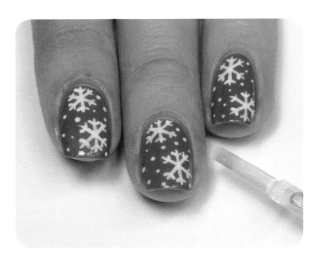

7 Finish with a top coat to seal the design and protect your manicure.

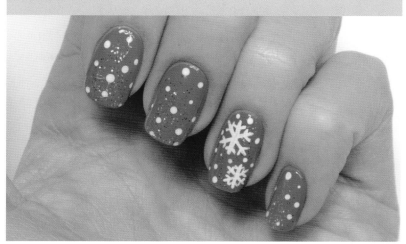

These snowflakes make a lovely accent design. After painting, apply clear glitter polish to all of your nails, then add small white dots to create the illusion of snow.

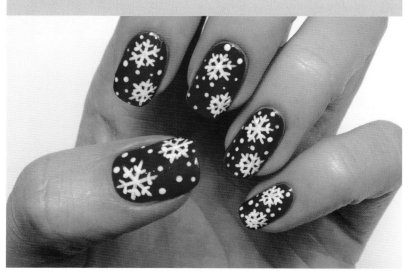

Use a dark red polish for the base color to give this design a festive holiday flair!

Happy Hanukkah

Express the festive colors and celebrations of Hanukkah with this easy design.

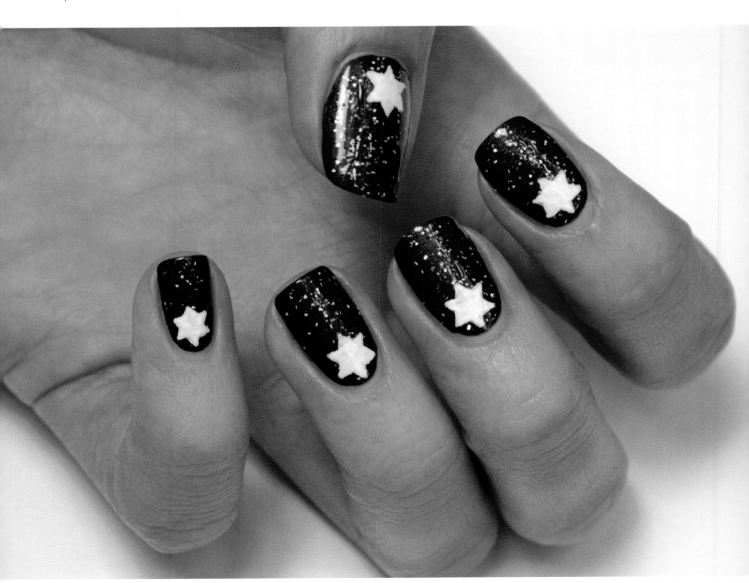

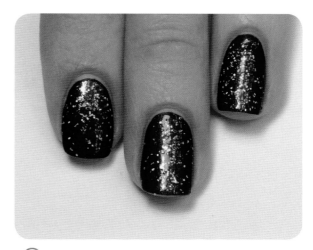

1 After your base coat has dried, paint your nails using royal blue polish.

2 Apply one layer of clear glitter polish.

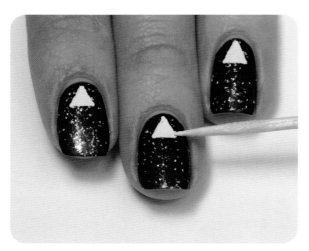

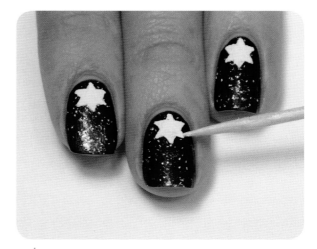

3 Use a toothpick and white acrylic paint to apply a triangle shape to the center of the nail near the cuticle area.

4 With the same tools, paint points that come out of the straight sides of the triangle. Doing so will form a six-pointed star. Finish with a top coat to seal the design and protect your manicure.

Christmas Presents

This design is an adorable way to show your holiday spirit during the gift-giving season.

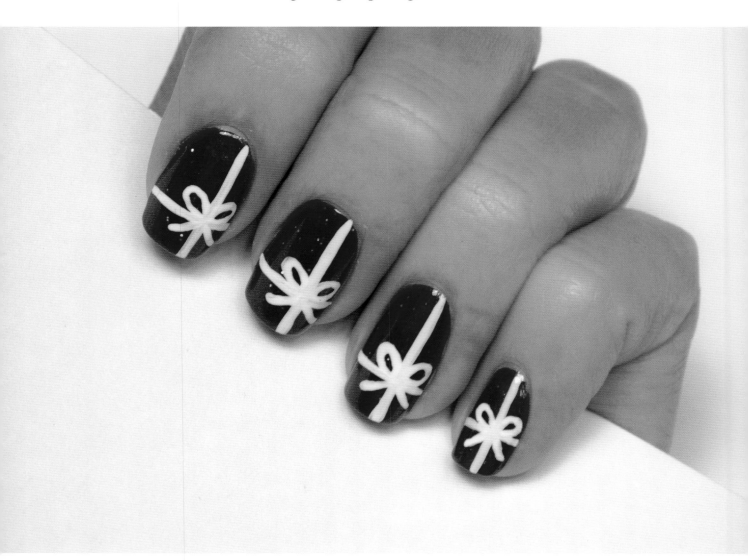

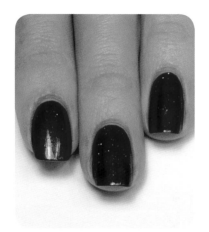 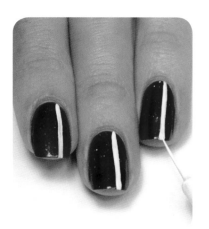 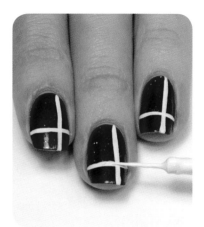

1 After your base coat has dried, paint your nails using a glittery dark red polish.

2 Use a white striper to apply a straight line going down the nail. Make sure the line is slightly off center.

3 With the same white striper, apply a line going across the nail. Make sure the line is slightly below the middle of the nail, closer to the tip.

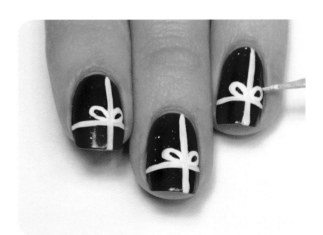 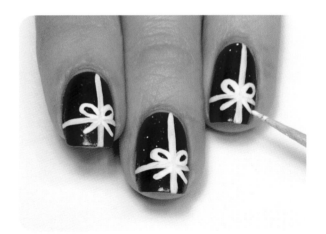

4 Use a toothpick and white acrylic paint to create two loops coming from the top of the intersecting lines.

5 With the same tools, apply two lines coming from the bottom of the intersecting lines to complete the bow. Finish with a top coat to seal the design and protect your manicure.

 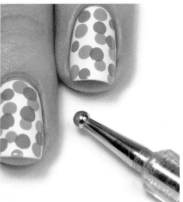 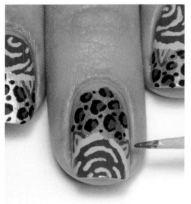 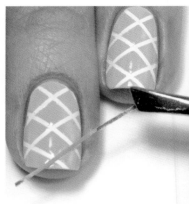

Below are some of the products I used to create the projects in this book. You can find these items at your local beauty supply store or drugstore. To learn more about these products, go to the manufacturers' websites listed below.

CND

www.cnd.com
Speedey Top Coat

Jason

www.jason-personalcare.com
Cocoa Butter Hand & Body Lotion

L'Oréal Paris

www.lorealparisusa.com
Colour Riche Nail Polish

Nutra Nail

www.nutranail.com
Nailsentials Cuticle Remover

Sally Hansen

www.sallyhansen.com
Complete Salon Manicure Dry & Go Drops, Complete Salon Manicure Polish, Diamond Flash Fast Drying Top Coat, Double Duty Strengthening Base & Top Coat, Vitamin E Nail & Cuticle Oil

Salon Perfect

www.salonperfect.com
Stripers

Wet n Wild

www.wnwbeauty.com
Megalast Nail Polish

Zoya

www.zoya.com
Remove Plus Nail Polish Remover

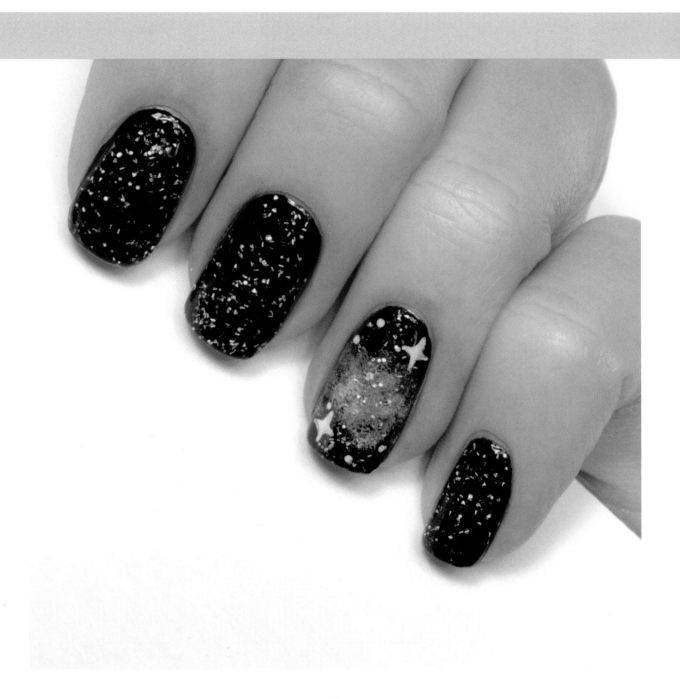

index

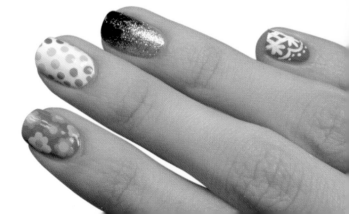

Other fine Fons & Porter books are available from your favorite bookstore, craft store or online supplier.

18 17 16 15 14 5 4 3 2 1

media
www.fwmedia.com

DISTRIBUTED IN CANADA BY FRASER DIRECT
100 Armstrong Avenue
Georgetown, ON, Canada L7G 5S4
Tel: (905) 877-4411

DISTRIBUTED IN THE U.K. AND EUROPE
by F&W Media International
LTD Brunel House, Forde Close, Newton Abbot, TQ12 4PU, UK
Tel: (+44) 1626 323200, Fax: (+44) 1626 323319
E-mail: enquiries@fwmedia.com

DISTRIBUTED IN AUSTRALIA BY CAPRICORN LINK
P.O. Box 704, S. Windsor NSW, 2756 Australia
Tel: (02) 4560-1600 Fax: (02) 4577 5288
E-mail: books@capricornlink.com.au

SRN: T1390
ISBN: 978-1-4402-4080-5

Edited by Christine Doyle and Noel Rivera

Designed by Julie Barnett

Photography by Hannah Lee

Production coordinated by Greg Nock

dedication

For Mom and Dad.
I love you both.

acknowledgments

I would like to thank my family for supporting me in my decision to do what I love. A special thanks to Amelia Johanson, Noel Rivera, Christine Doyle and everyone else involved in helping my dream become a reality. And last, but definitely not least, to all my subscribers: thank you for the amazing support you've given me. You inspire me to continue to create and share my art with the world.

about the author

Hannah Lee is a professional manicurist and nail artist who has always had a passion for art. Halfway through nail tech school, she realized what great canvases nails can be! That's when she decided to start her nail channel on YouTube (youtube.com/hannahroxnails) in October of 2010. Since then, her videos have reached millions of viewers and that number continues to grow. Her work has been featured in *Girls' Life Magazine, NAILS Magazine, Nail It! Magazine* and on TeenVogue.com. She has also worked with Sally Hansen, Sephora and Physicians Formula.

Try some of our other great titles.

The Crafter's Book of Clever Ideas

BY ANDREA & CLIFF CURRIE

Try these twenty-five fun projects with his and hers variations for a total of fifty unique, gift-giving and party ideas. These clever techniques use a wide range of materials, including glitter, glass, felt and glue gun resin. Pick projects to make at parties or throw your own shindig with mosaic partyware, confetti poppers and booby-trapped gifts! There's something for every occasion with plenty left over for crafting fun at home.

ISBN: 978-1-4402-3807-9 SRN: U6489

DIY Nail Art

BY CATHERINE RODGERS

Catherine Rodgers, creator of the popular nail art YouTube Channel Totally Cool Nails, shares her secrets in *DIY Nail Art*. Packed with easy-to-follow instructions and helpful tips for recreating Catherine's stunning looks, you can create one-of-a-kind nail art designs without ever stepping inside a nail salon. Inside this colorful guide, you'll find seventy-five eye-catching designs, including never-before-seen styles like Argyle, Light Burst and Spiderweb Nails.

ISBN: 978-1-4405-4517-7 SRN: V9991